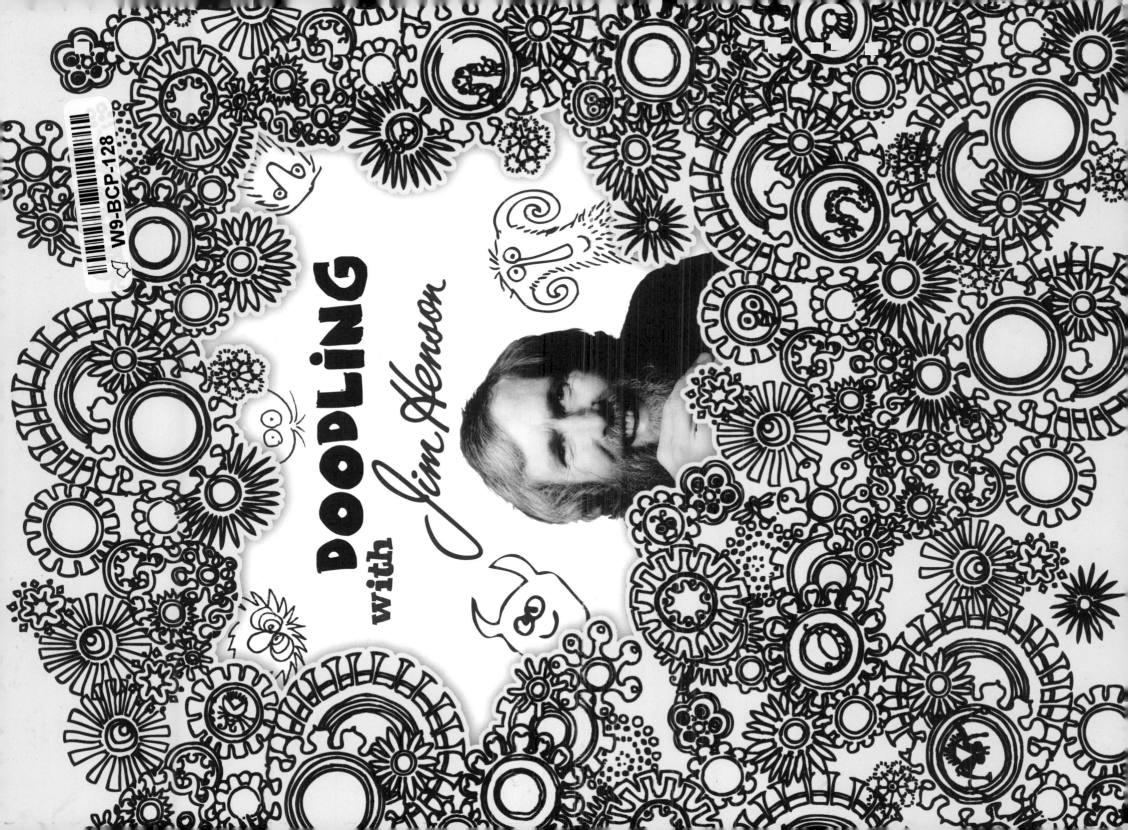

DOODLING
with Jim Henson

Associate Publisher: Elizabeth T. Gilbert

Project Editor: Rebecca J. Razo

Art Director: Shelley Baugh

Production Artists: Debbie Aiken, Amanda Tannen

Production Manager: Nicole Szawlowski

International Purchasing Coordinator: Lawrence Marquez

Doodling exercises written by Rebecca J. Razo

www.walterfoster.com

Walter Foster Publishing,

a Division of the Quayside Publishing Group

3 Wrigley, Suite A

Irvine, CA 92618

Printed in China.

7 9 10 8 6

18495

DOODLING
with *Jim Henson*

Foreword

My father began his creative career as a graphic artist designing posters and logos in college. He was accustomed to expressing himself through pictures and was a prolific doodler; visualizing his ideas on paper was a part of his work process. Some of my father's most popular characters began as simple scribbles or sketches. I am often amazed at how a few of his simple drawn lines can so clearly show an emotion or an expression. And while the final look of the character he created was often quite different from how it started, the essence of the character's personality frequently reflected that very first inspirational sketch.

Expressing ideas on paper, either by capturing that flash of creativity or by allowing a doodle to wander aimlessly across the page, is a great way to explore the inner artist in each of us. Who knows where your scribbles may lead you? To another land? To a new friend? To a different way of understanding the world around you? Embracing your imagination can invite all kinds of adventures, so grab a pen (or pencil, crayon, marker or paintbrush!) and begin your own journey.

Lisa Henson, CEO
The Jim Henson Company

How to use this book

"When I was young," Jim Henson once said, "my ambition was to be one of the people who make a difference in this world. My hope still is to leave the world a little bit better for my having been here." Although Jim Henson's untimely passing in 1990 left a gaping void in the lives of his family, friends, and fans around the world, he did accomplish his dream. Indeed, the world is much better thanks to the brilliant contributions of this most beloved puppeteer.

But Jim Henson was much more than that. He was a movie maker; an entertainer; and a clever, visionary artist whose playful side spoke as much to his personality as the cherished characters he created. And now, for the very first time, Jim Henson fans are given an opportunity to draw inspiration from—and participate in—Jim's wonderfully imaginative, colorful world through this interactive doodle book.

Part One of this book, "Jim Henson's Sketchbook," features a collection of doodles, sketches, and scribbles taken directly from Jim's personal sketchbooks and note pads. Learn about Jim's life and career while browsing each page filled with Jim's whimsical, offbeat, and delightful doodles. Then, after you've taken a moment to peek inside the mind of this extraordinary artist, you'll move on to Part Two of the book, "The Scribbles."

Everybody scribbles. And it's not just for kids! Doodling and scribbling have long been enjoyable pastimes. From prehistoric cave drawings at the dawn of man to innovative creations scrawled in college notebooks, people of all ages through the ages have sketched and scribbled. Think about it. Today, when you're sitting in that meeting with the boss or while you're trying to stay awake in the sales presentation that just won't end, you'll instinctively pick up your pen or pencil and doodle a

Funny creature to alleviate your boredom. You may even scribble a rocket ship so that you can escape to the stars, or perhaps you'll doodle a lottery ticket with the winning numbers!

Jim Henson Designs: Scribbles are the elements of our own psyche and imagination, brought to life by the magic of Jim Henson. Inspired by Jim's original artwork, the Scribbles are characters that embody our pent-up emotions, as well as our hopes, dreams, and fears. If you've got something to express—good or bad, happy or sad—we invite you to do so on the pages of this book, right alongside the Scribbles, whose range of emotions mirror ours in every imaginable way.

"The Scribbles" section also invites doodle enthusiasts to embark on a fun and whimsical journey of creative self-expression through a variety of imaginative drawing prompts and exercises, using Jim Henson Designs: Scribbles as their muses and guides. These exercises serve no particular purpose other than to connect you to your artistic side and offer you an enjoyable outlet for total creativity. There are guidelines and suggestions, but there are no RULES! This is your doodle book, after all!

We're positive that after you work your way through this book—as often or as little as you like—you'll agree with Jim's philosophy that "We never really lose a certain sense we had when we were kids." And if you think that you might have lost that sense somewhere along the road of your adult life, one thing's for certain: you're sure to find it again after Doodling with Jim Henson.

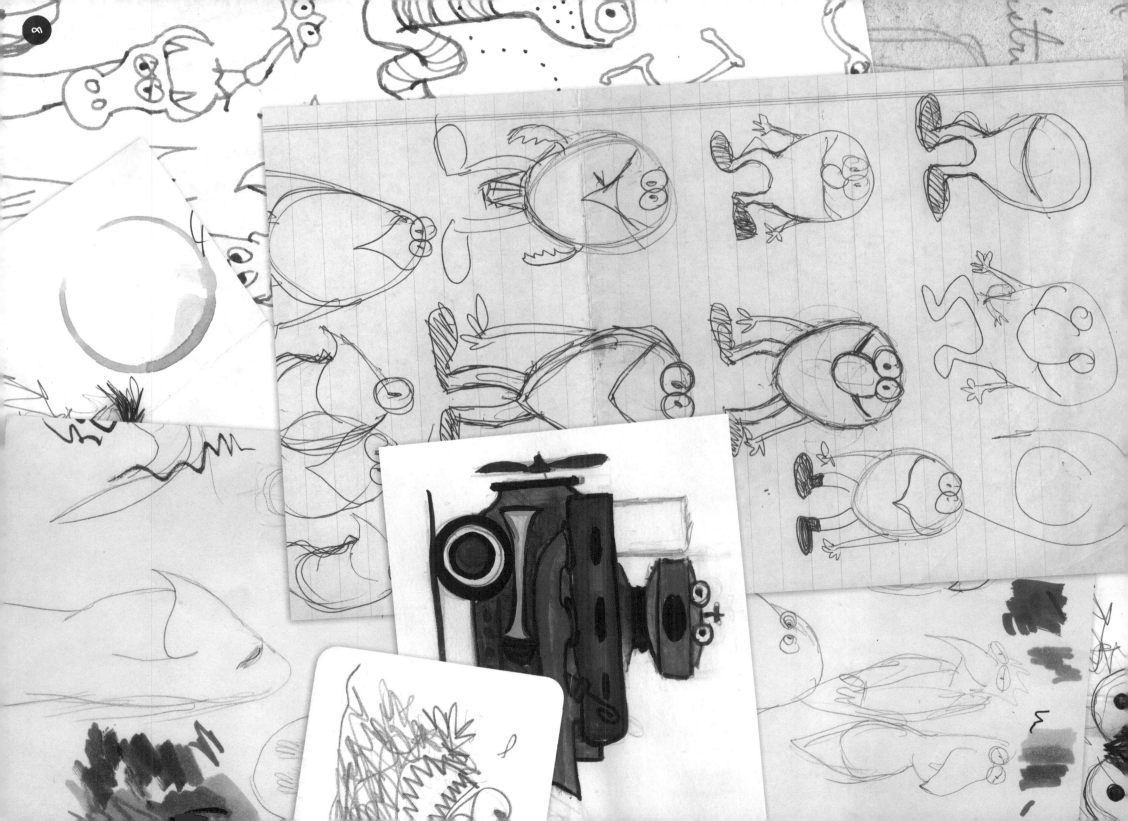

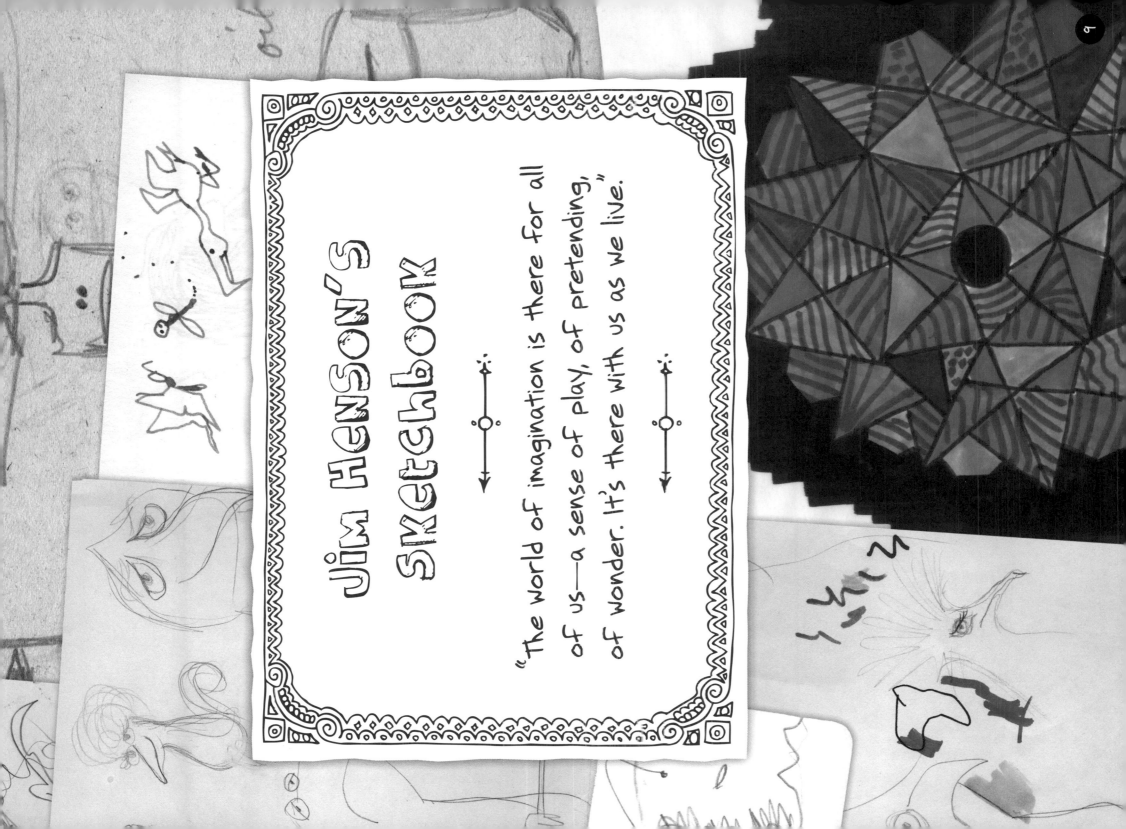

Jim Henson's Sketchbook

"The world of imagination is there for all of us—a sense of play, of pretending, of wonder. It's there with us as we live."

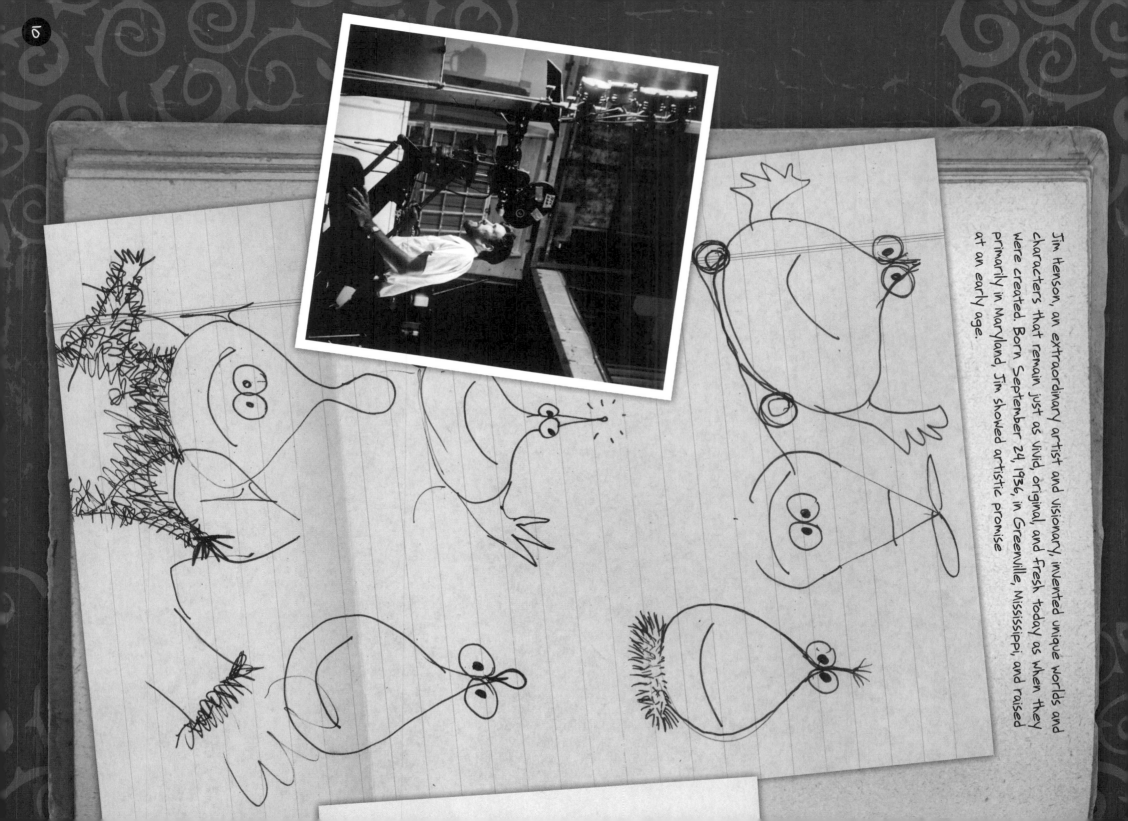

Jim Henson, an extraordinary artist and visionary, invented unique worlds and characters that remain just as vivid, original, and fresh today as when they were created. Born September 24, 1936, in Greenville, Mississippi, and raised primarily in Maryland, Jim showed artistic promise at an early age.

In 1954, while still in high school, Jim began puppeteering for a local Washington, D.C. Saturday-morning TV program. Later, while he was a freshman at the University of Maryland, Jim was given a twice-daily, five-minute TV show called Sam and Friends.

The success of Sam and Friends, which also featured an early version of the beloved Kermit the Frog, led to many guest appearances on national network TV programs. From there, Jim's career began to skyrocket. Now married to his puppeteering partner, Jane Nebel, Jim and his growing family relocated to New York in 1963.

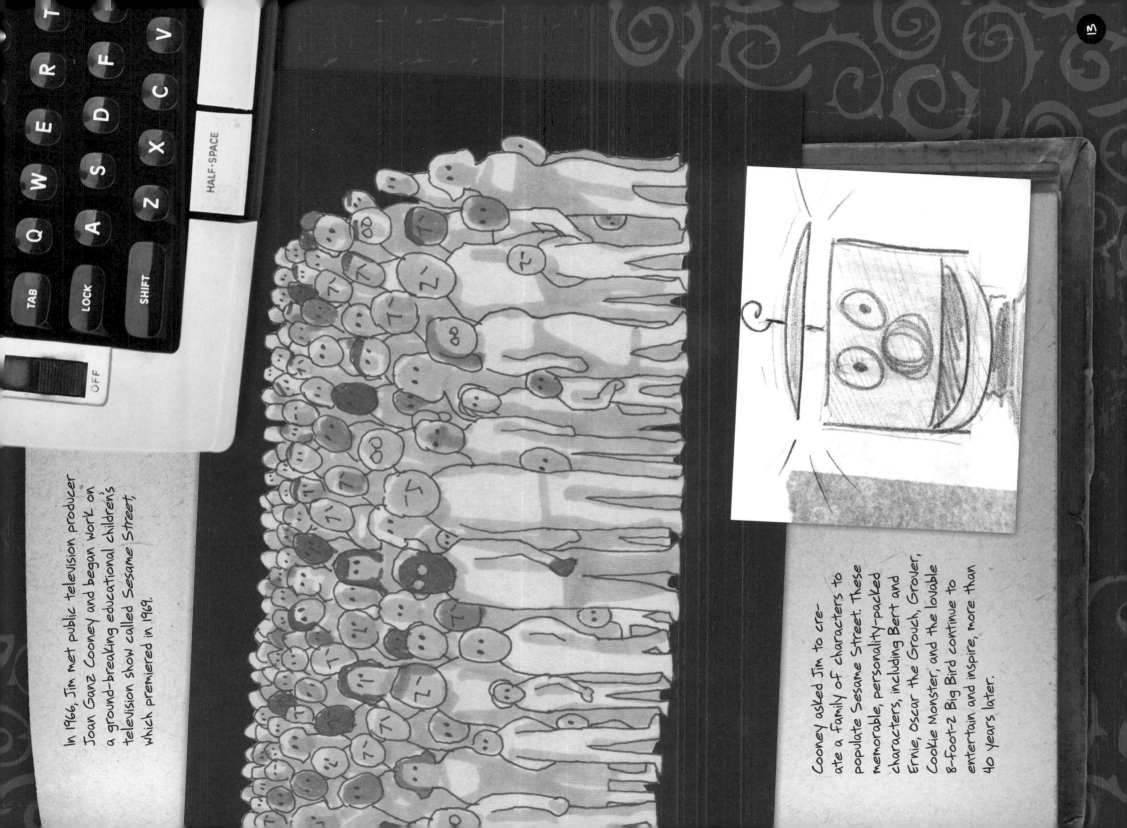

In 1966, Jim met public television producer Joan Ganz Cooney and began work on a ground-breaking educational children's television show called Sesame Street, which premiered in 1969.

Cooney asked Jim to create a family of characters to populate Sesame Street. These memorable, personality-packed characters, including Bert and Ernie, Oscar the Grouch, Grover, Cookie Monster, and the lovable 8-foot-2 Big Bird continue to entertain and inspire, more than 40 years later.

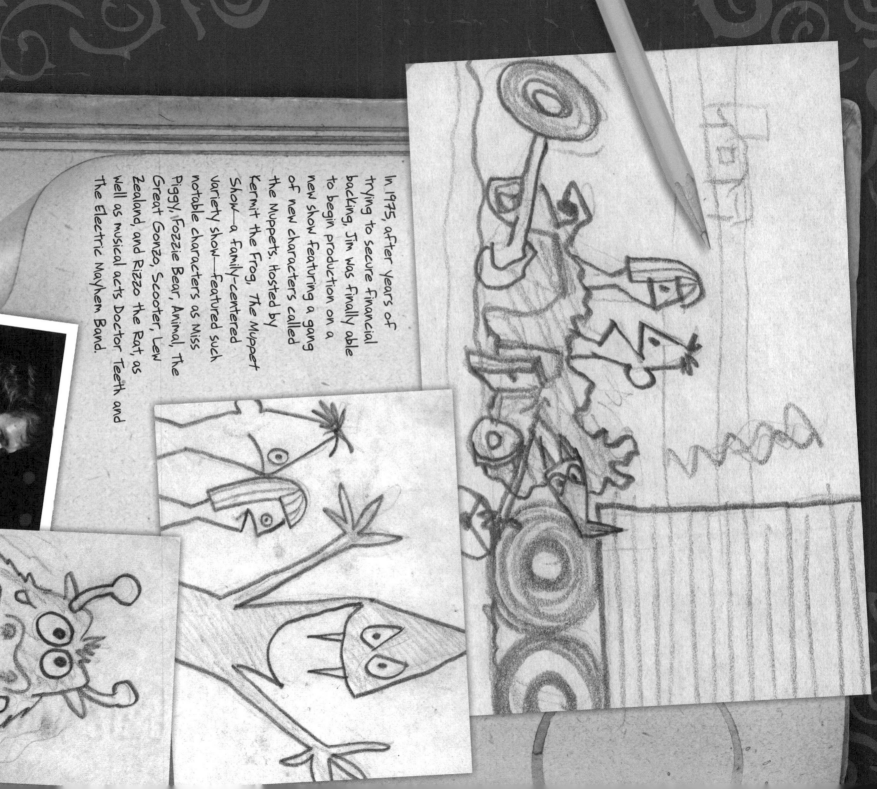

In 1975, after years of trying to secure financial backing, Jim was finally able to begin production on a new show featuring a gang of new characters called the Muppets. Hosted by Kermit the Frog, The Muppet Show—a family-centered variety show—featured such notable characters as Miss Piggy, Fozzie Bear, Animal, The Great Gonzo, Scooter, Lew Zealand, and Rizzo the Rat, as well as musical acts Doctor Teeth and The Electric Mayhem Band.

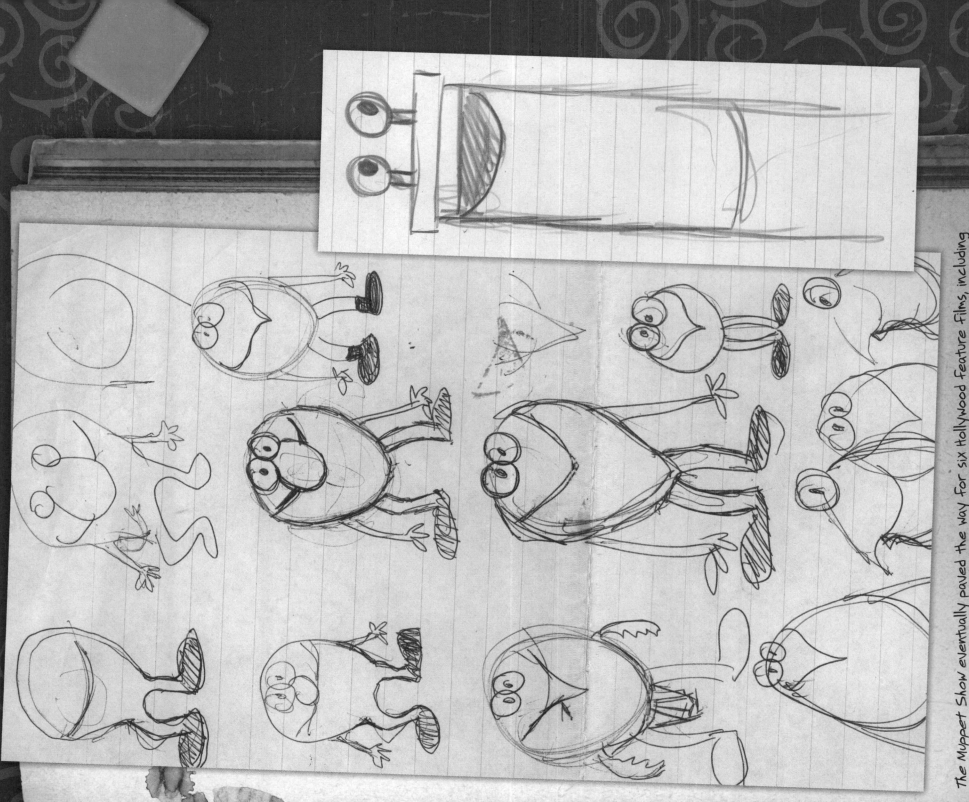

The Muppet Show eventually paved the way for six Hollywood feature films, including The Muppet Movie, The Great Muppet Caper, The Muppets Take Manhattan, The Muppet Christmas Carol, Muppet Treasure Island, and Muppets From Space.

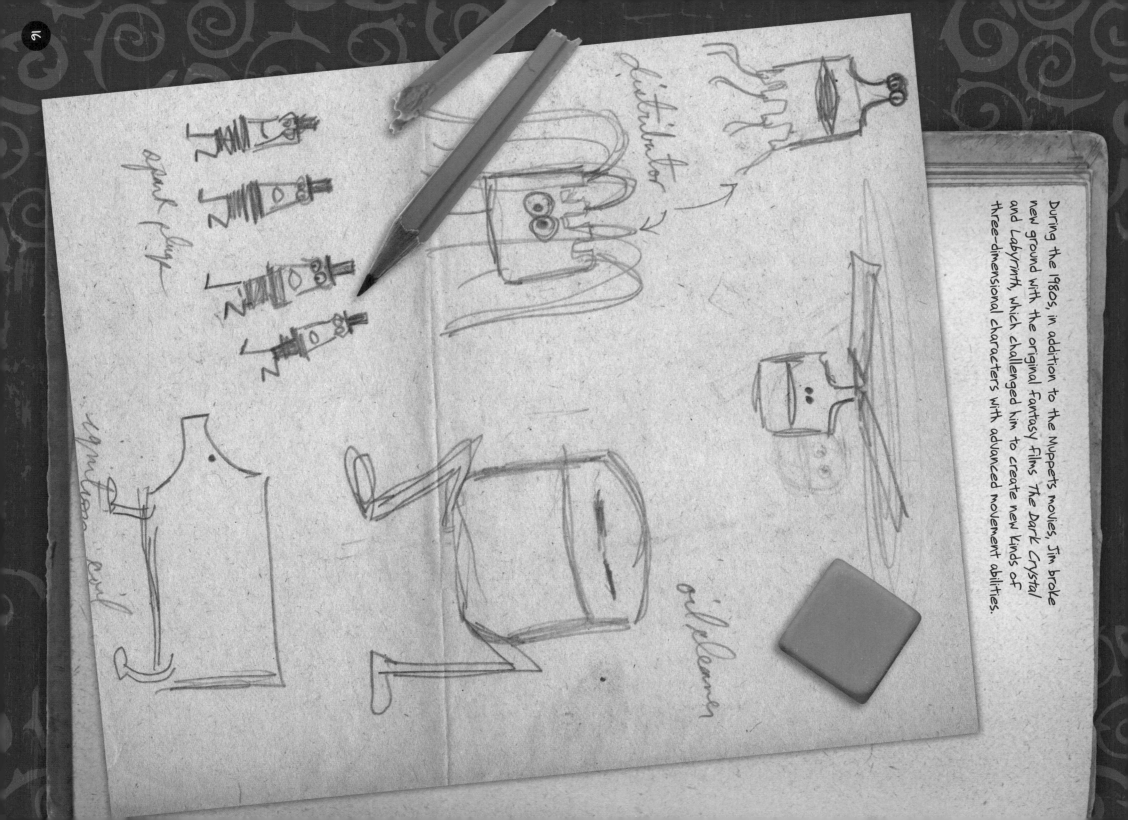

During the 1980s, in addition to the Muppets movies, Jim broke new ground with the original fantasy films The Dark Crystal and Labyrinth, which challenged him to create new kinds of three-dimensional characters with advanced movement abilities.

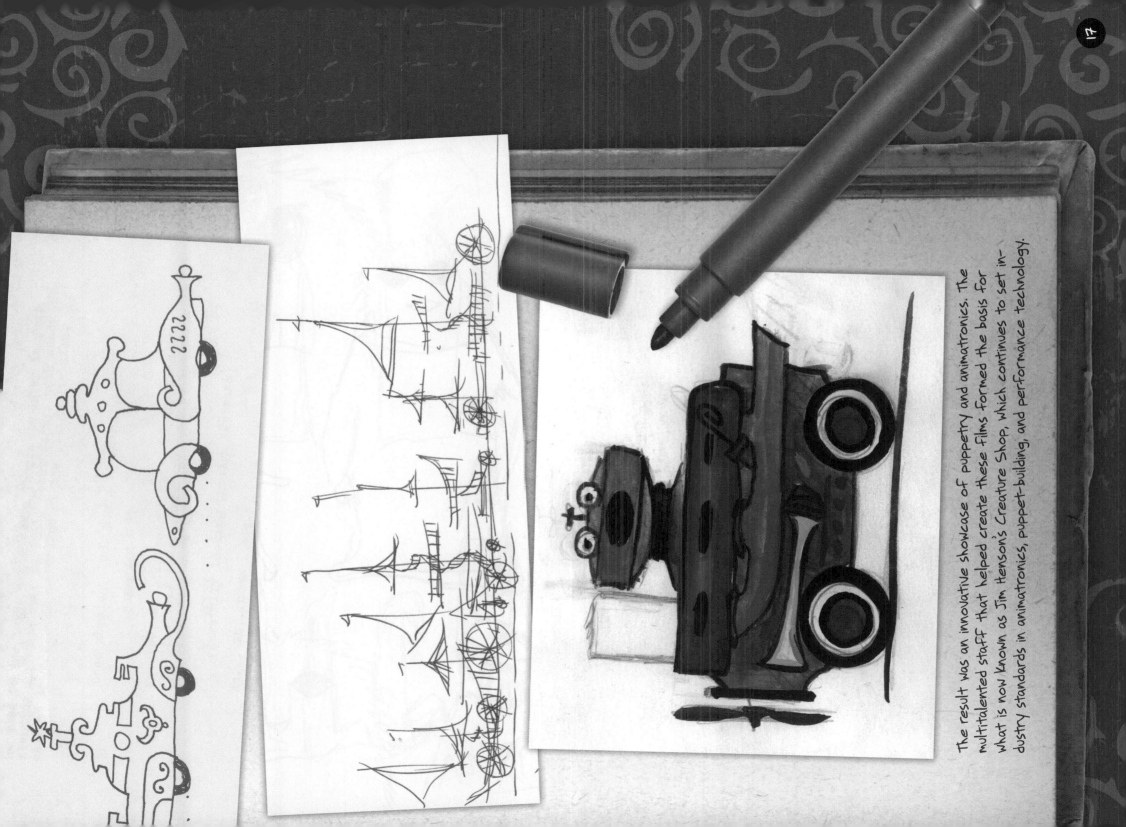

The result was an innovative showcase of puppetry and animatronics. The multitalented staff that helped create these films formed the basis for what is now known as Jim Henson's Creature Shop, which continues to set in-dustry standards in animatronics, puppet-building, and performance technology.

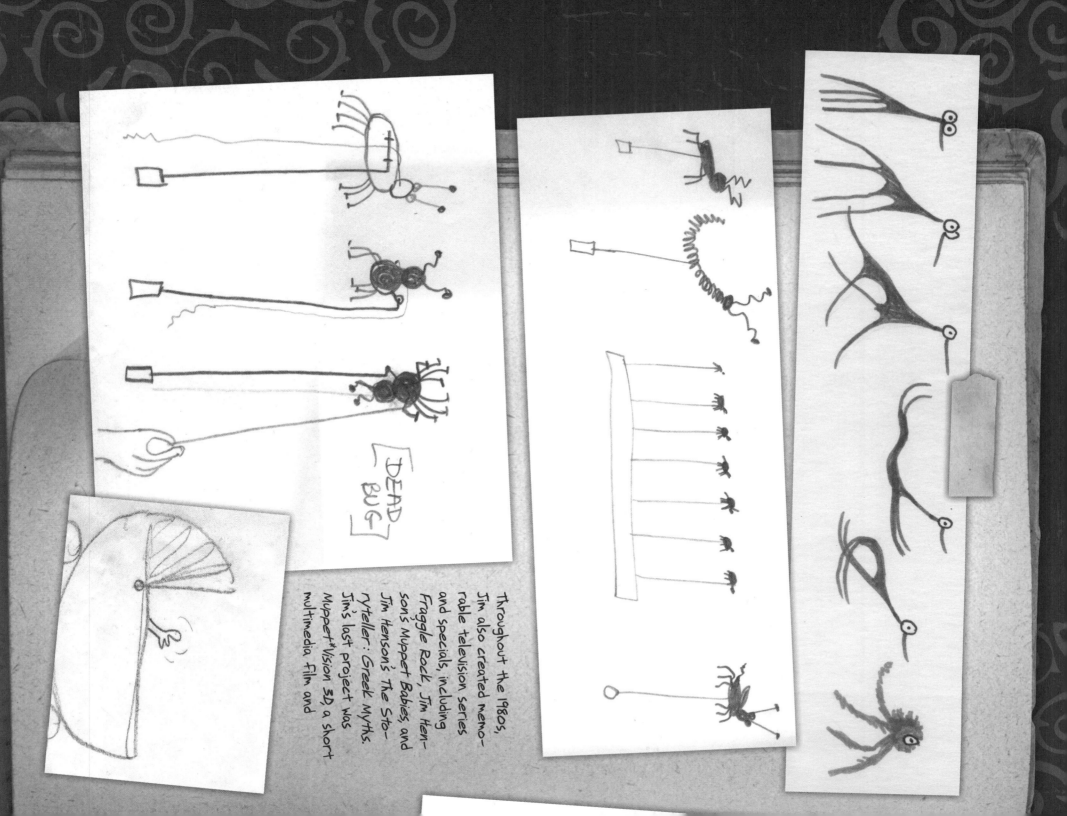

DEAD BUG

Throughout the 1980s, Jim also created memo-rable television series and specials, including Fraggle Rock, Jim Henson's Muppet Babies and Jim Henson's The Sto-ryteller: Greek Myths. Jim's last project was Muppet*Vision 3D, a short multimedia film and

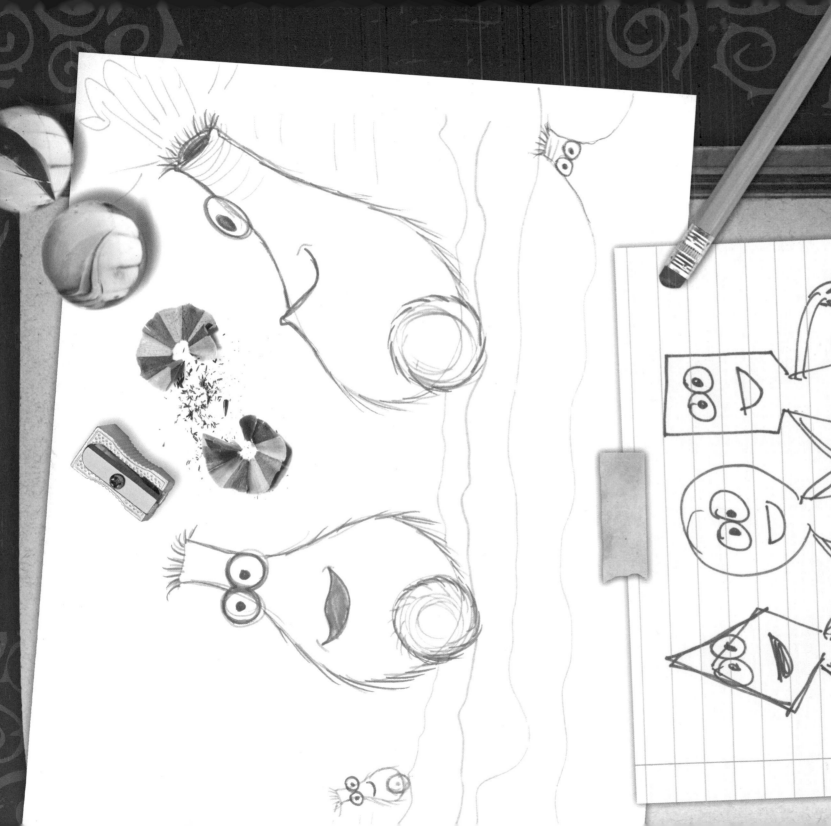

interactive attraction, which is currently featured at Disney's Hollywood Studios at the Walt Disney World Resort in Orlando, Florida, and Disney's California Adventure in Anaheim, California.

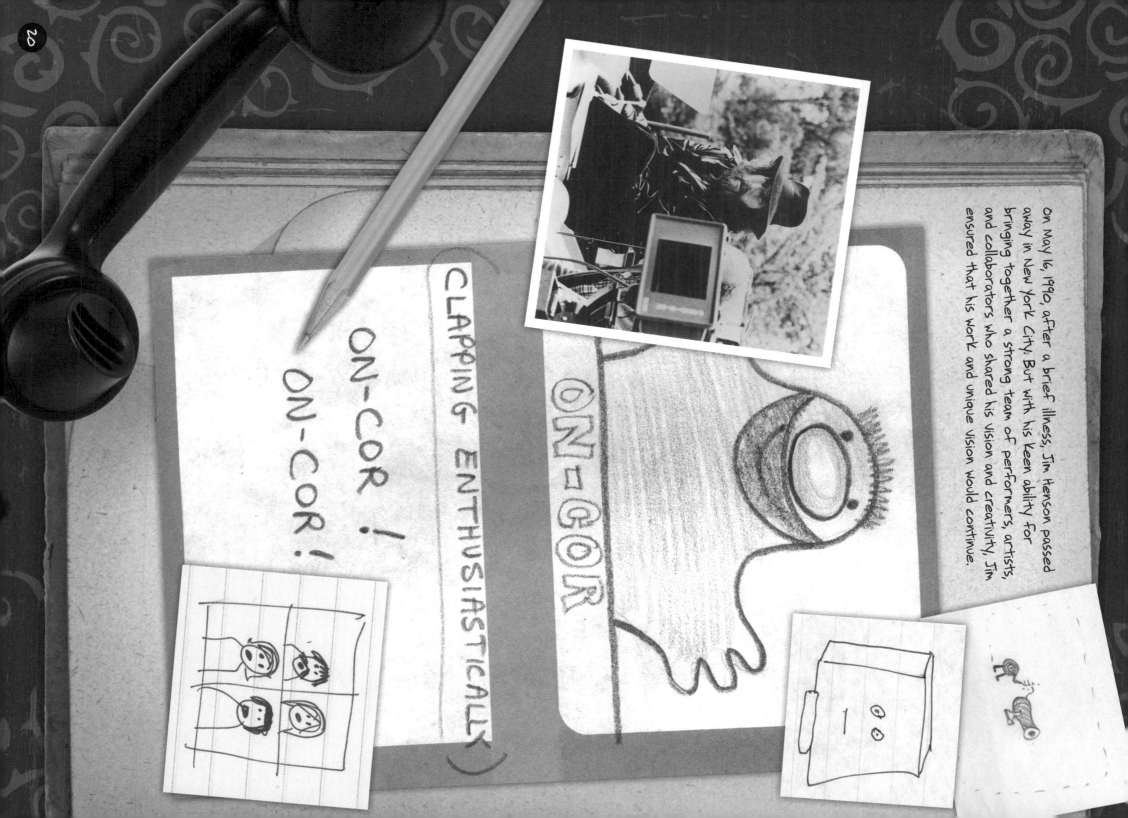

On May 16, 1990, after a brief illness, Jim Henson passed away in New York City. But with his keen ability for bringing together a strong team of performers, artists, and collaborators who shared his vision and creativity, Jim ensured that his work and unique vision would continue.

CLAPPING ENTHUSIASTICALLY)

ON-COR!
ON-COR!

ON-COR

ON=COR

ONGOING

ENCORE MEANS
YOU WANT
MORE

Today, through The Jim Henson Company, Jim's brilliant
and imaginative work continues to captivate, entertain,
and inspire not only a global audience, but also new
generations of fans.

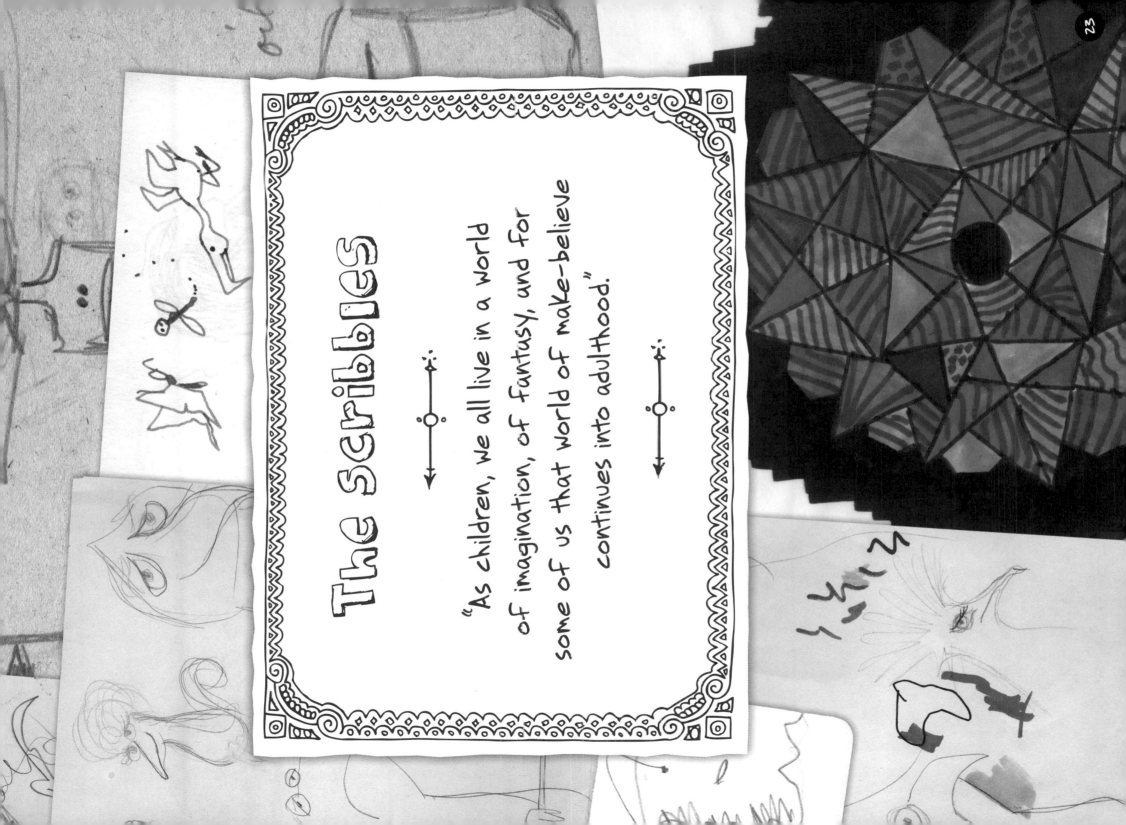

The Scribbles

"As children, we all live in a world of imagination, of fantasy, and for some of us that world of make-believe continues into adulthood."

This Scribble is a *dreamer*

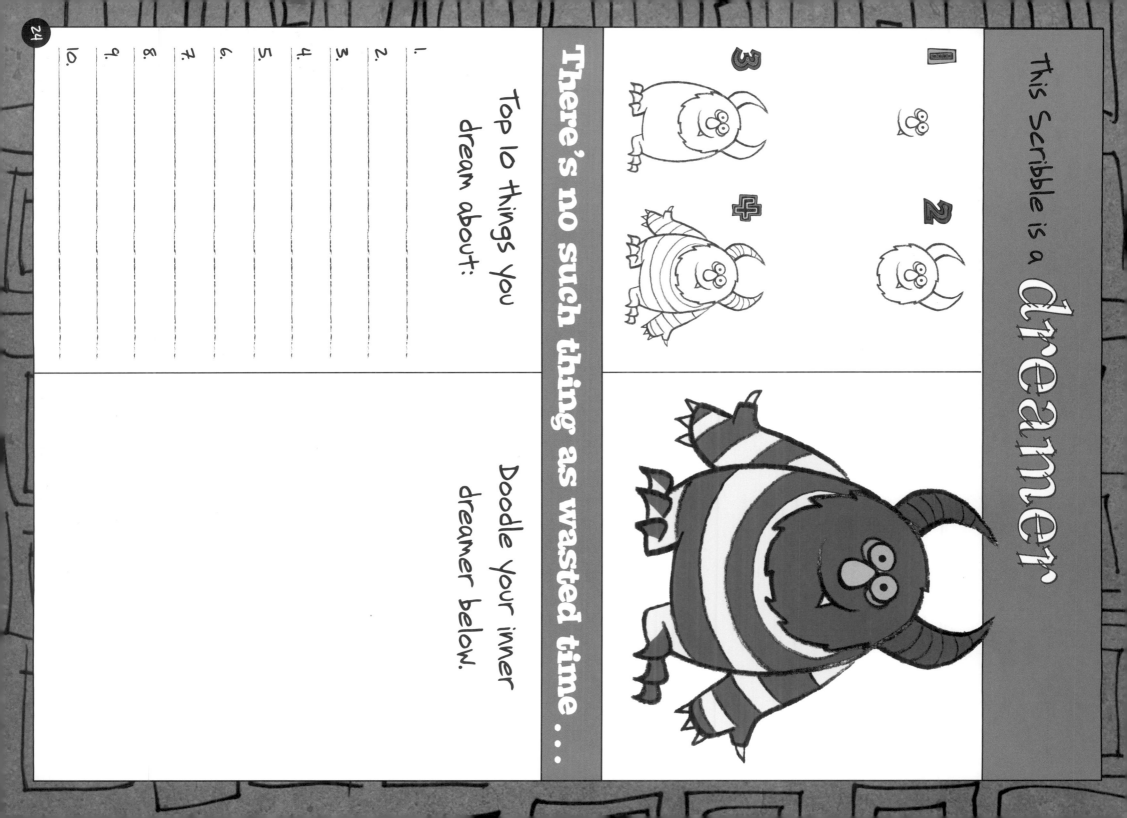

1

2

3

4

There's no such thing as wasted time

Top 10 things you dream about:

1.
2.
3.
4.
5.
6.
7.
8.
9.
10.

Doodle your inner dreamer below.

Dream it now and do it later.

This Scribble is the dreamer in you who gazes off into the clouds and imagines something greater. For this Scribble, a cloud is never a cloud. It's a castle besieged by dragons. It's a two-headed turtle wearing a jet pack. No matter what it is, this guy somehow sees the magic hidden within. Sure, he's a tad idealistic and impractical at times. He's rarely prepared for the countless obstacles standing in the way of his ambitious dreams. Yet that never stops this Scribble. In his heart beats the hope in all of us for grander possibilities and greater thrills. That spirit who dares to ascend beyond the norm and achieve the extraordinary. So in the end, it's dreamers like this Scribble that inspire us to succeed, just because he believes we all can.

What does your dream life look like? Doodle it here.

Still dreaming? Let your creativity flow freely on these pages.

What's this Scribble dreaming of?

What has captured this Scribble's attention?

What are these fellas thinking about?
Doodle or write their thoughts
in the space provided.

This Scribble is a **glutton**

1

2

3

Now means NOW!

Doodle your inner glutton below.

Top 10 things you want right now:

1.
2.
3.
4.
5.
6.
7.
8.
9.
10.

"No" isn't in my vocabulary

Deep inside everyone is a shameless glutton—the greedy voice urging you to buy that new gadget, eat that last potato chip, and hog the spotlight. This part of you is lured by infomercials, tempted to compete for affection and attention, and possessive over the most trivial things. This part of you wants it all now—before anyone else. And if you don't get it? May the world prepare for a colossal tantrum, because nothing is so fierce as a consumer scorned. So don't dare say "no" to this Scribble. Them's fightin' words! This Scribble isn't a bad guy, though. He rarely intends to step on people's toes. He just can't help himself. In fact, he's genuinely shocked to see such destruction in his wake. And he's quick to deliver a big, apologetic hug when he's crossed the line. He might even share a potato chip or two. Sure, he'll devour the rest in seconds, but for him, sharing even a morsel is a big gesture. But his heart is always in the right place. If only he listened to that before his stomach.

If you could snap your fingers and have anything you want, what would it be? Doodle it here.

Feeling a little gluttonous?
Satisfy your doodle cravings here.

Practice doodling a self-portrait...

...then do it again for your personal portrait gallery.

If the Scribble at left had a family of six, what would they look like?

Doodle them here.

DATE

PAGE

PREPARED BY

40

Draw these Scribbles in a setting (on the subway, at a diner, in outer space?) and write a short story or dialogue to go with the scene.

This Scribble is a _lump_

1

2

3

+

I'm busy doing nothing

Top 10 favorite couch
potato activities:

1.
2.
3.
4.
5.
6.
7.
8.
9.
10.

Doodle your inner
lump below.

Life is too short to leave the couch

Wanna know why it was impossible to get out of bed? Why you spent the whole day on the couch watching TV marathons? Meet this lazy Scribble. To this lethargic lump, the perfect day is one spent doing absolutely nothing. She cherishes peace, indifference, and utter passivity. No obligation or conflict is worth moving off the couch for. In fact, moving off the couch is exhausting. She'll need a nap just to recover! And once she's in bed, you'll need a crane to pry her out again. To her, bed is bliss. The only time you'll see this lump moving is when she's avoiding responsibility. She'll run the 100-meter dash in seconds if it means escaping a pesky chore. She'll also trek across the globe in search of the ultimate universal remote. But if you ask her to do something? Sure, she'll do it... just as soon as her TV show is over. And her food is done cooking. And after her post-lunch nap, of course. Don't wait around for her, though. She'll lure you right onto that couch with her!

How do you spend your time doing nothing? Doodle it here.

Don't feel motivated enough to doodle? That's O.K. Just leave these pages blank and save them for later.

This book tells the story of your life.
Doodle the cover art to fit the story.

Is there something you want the world
to know about you? Doodle it on this billboard.

This Scribble is a **Wild child**

3

2

4

Life should be lived in the WILD lane

Doodle your inner wild child below.

Top 10 things that energize you:

1.
2.
3.
4.
5.
6.
7.
8.
9.
10.

Coffee Overload!

Ever had too much sugar? You devour some candy or chocolate (maybe both), down a few sodas, and suddenly you feel as though you're losing control. As if you need to explode from your chair, lift off like a rocket, and zoom around the world ten times over! That is your wild child. This Scribble, who hits that pad of paper with speed, is sugar incarnate. His judgment is blurred. His movements are blurred. He's just so hyper, so fast, so scattered—he can barely control himself. Given his frenetic nature, he is typically the friend you wish you hadn't invited over. That huge, devilish grin says it all. Even if you could punish him, you couldn't catch him. Those tiny legs are super fast! He'll dart into the kitchen turning on every appliance and faucet, and then scamper away as all the fuses blow. Turn your back, and he's on the roof gnawing on the TV antenna or unleashing the Rottweiler in your neighbor's yard. When calm, this guy is one of the sweetest souls around. Just watch out for the sugar. It's like fuel to this little one, and man can he fly!

What superhuman power would you like to possess?
Doodle it here.

Energy overload? Unleash your creative beast on these pages.

52

Draw each Scribble's alter ego in the space provided.

Doppelgängers

Draw wildly imaginative bodies for these heads.
(Six legs, three arms, and two necks are acceptable!)

This Scribble is a **goth girl**

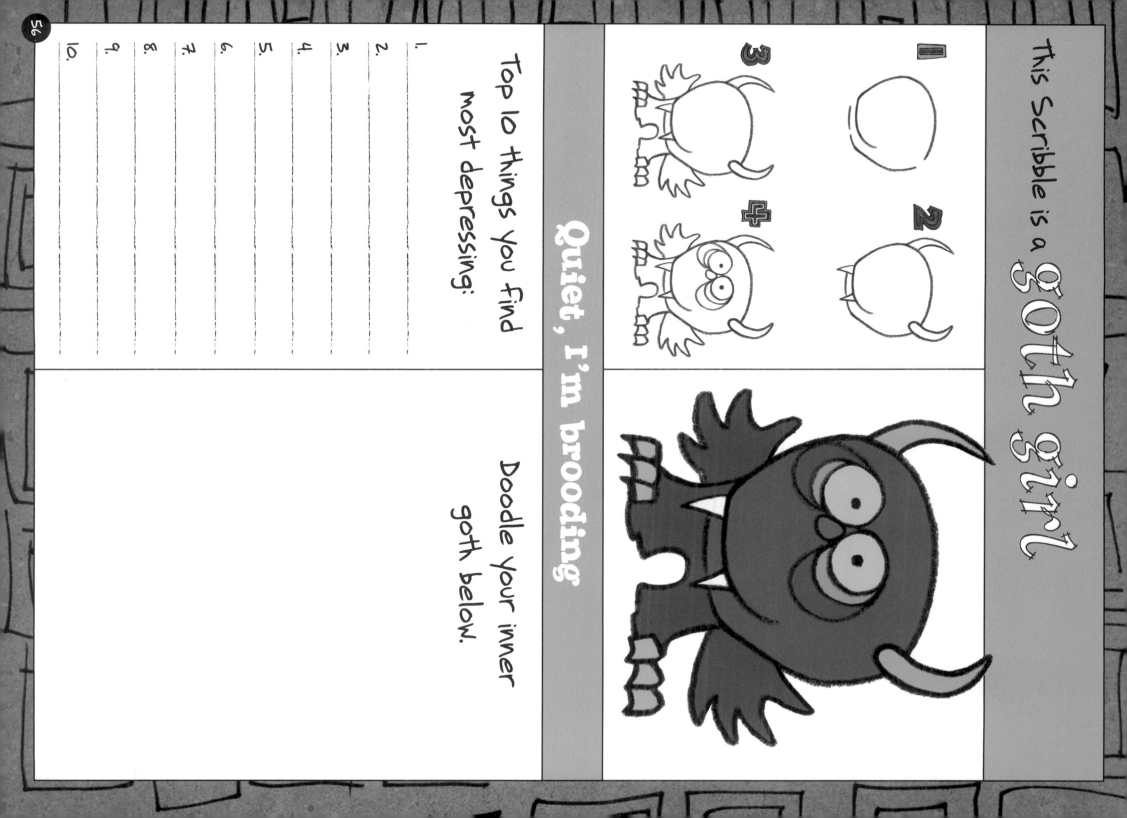

2

3

+

3

Quiet, I'm brooding

Top 10 things you find most depressing:

1.
2.
3.
4.
5.
6.
7.
8.
9.
10.

Doodle your inner goth below.

I am an endless abyss of disillusionment

Our goth girl Scribble is the classic dark-hearted soul that everyone can relate to at least once in a while. She is cloudy with a chance of rain. She prefers dim candlelight to sunshine and only reads stories with tragic endings. Bittersweet is too sweet for our melodramatic Scribble. Her favorite hobby is "brooding," and she will deliberately extinguish the optimism in anything around her. So if she's not reciting morbid poetry, she's sitting in the dark, listening to some manic-depressive band whining about its feelings. In fact, the only time she's happy is when others mistake her for a monster. She actually likes that. Don't let her fool you, though. This Scribble has a big heart. Her criticisms of the world are valid, and she blogs about them with abandon. She simply wants everyone to think, act, and live better. And who can fault her for that?

What would you change about the world if you could?
Doodle it here.

Wait until you feel really, really, really sad to doodle on these pages.

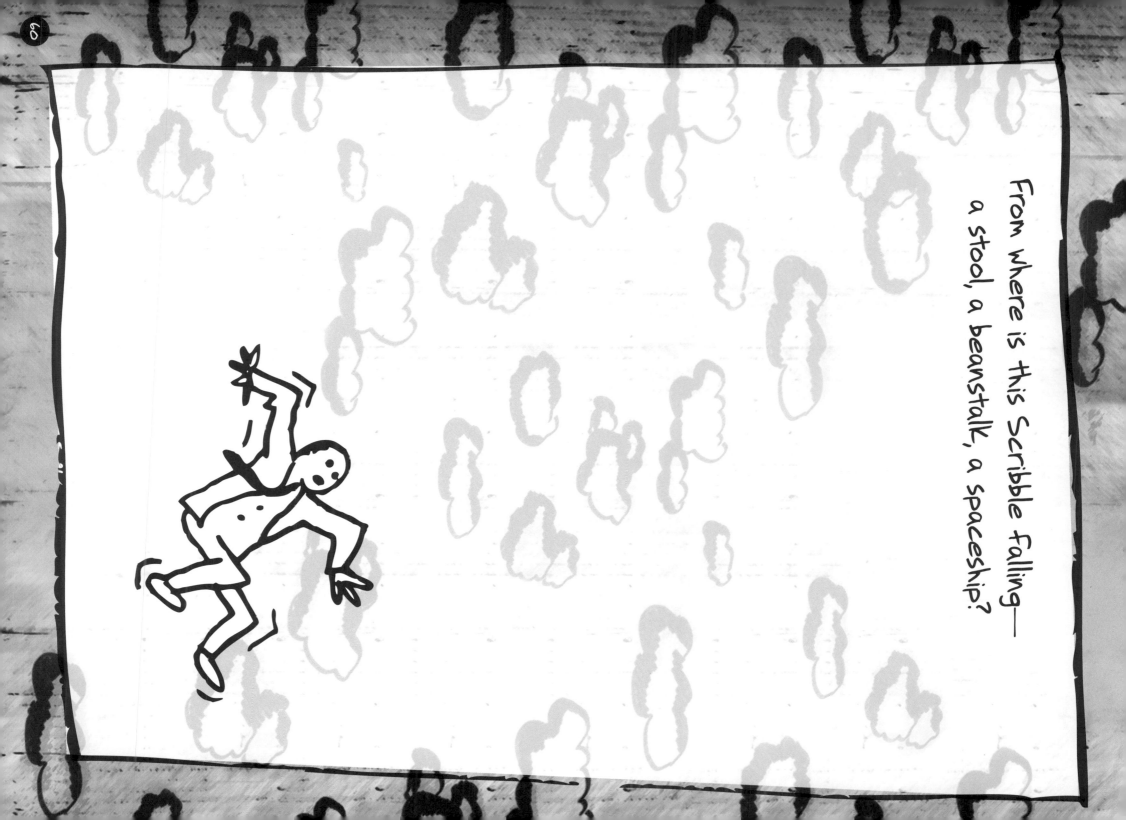

From where is this Scribble falling—
a stool, a beanstalk, a spaceship?

Where will this Scribble land—on a mattress, in a swimming pool, into the open mouth of a dinosaur?

This Scribble is a Weirdo

1

2

3

100% original

Top 10 weirdest things about you:

1. _____
2. _____
3. _____
4. _____
5. _____
6. _____
7. _____
8. _____
9. _____
10. _____

Doodle your inner weirdo below.

I was born this way

Some call this Scribble unique. Others call him weird. A few ask him to stop staring after an uncomfortably long span of time. No matter where he is, this guy can't help being artistically different. It's as though he simply doesn't comprehend how to function in normal situations. No, you shouldn't lick the house guests. No, you shouldn't spend 30 minutes highlighting the milestones of the mayonnaise industry. No, don't ask plants out to dinner. At times, he'll be so withdrawn, you'll wonder if he's sleeping with his eyes open. Other times, he'll act as though you're the only person on the planet and find every word you say fascinating, only to leave the room mid sentence to put peanut butter in your toaster. Why? Because the toaster was hungry. He's also the one friend who'll support any harebrained scheme. In fact, he'll convince all your other friends to join in! His unflappable confidence is inspiring, and you'll never meet another soul more comfortable in his own skin. So despite his quirks, this weirdo is a great friend!

What makes you unique? Doodle it here.

Weird is the new cool—at least that's what we like to tell ourselves. Doodle anything weird here.

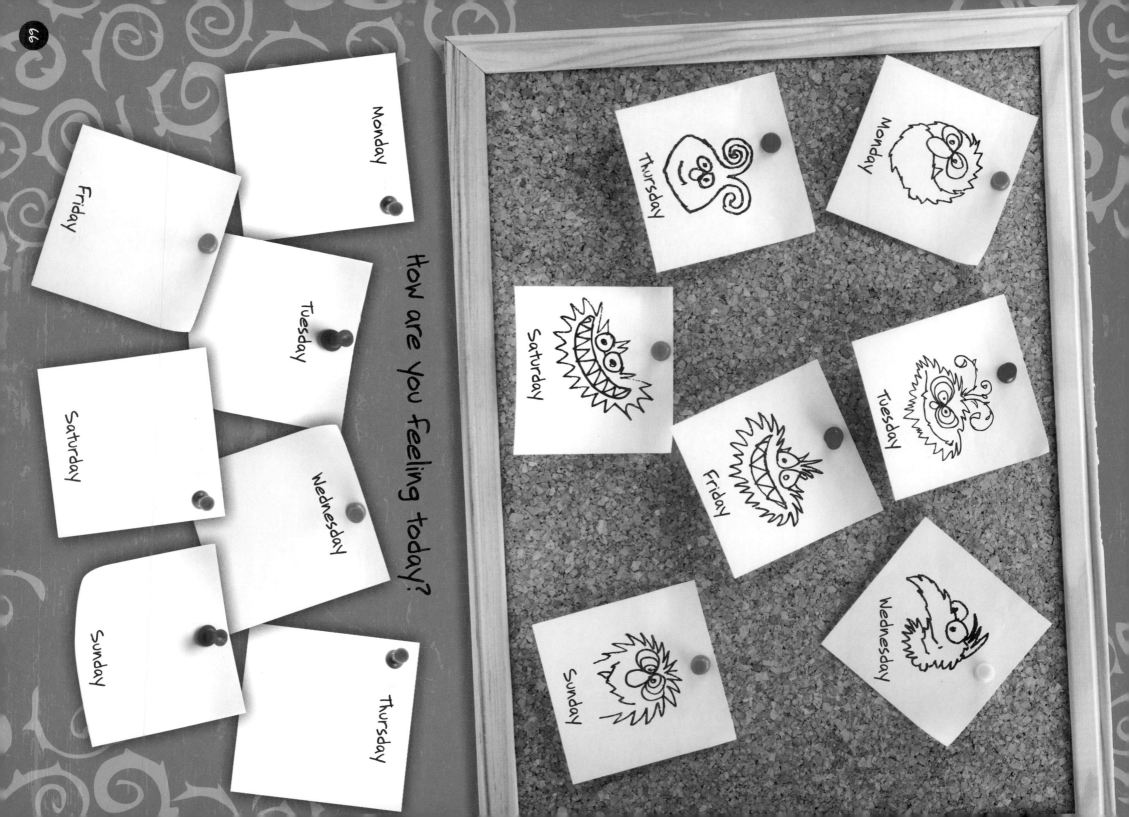

How are you feeling today?

Expressive Scribbles

Your Worst Day

Your Best Day

Your Every Day

Re-create the montage, or use it as inspiration and doodle an original.

Something's fishy. Doodle more fish in bizarre shapes, sizes, and colors.

This Scribble is a *trickster*

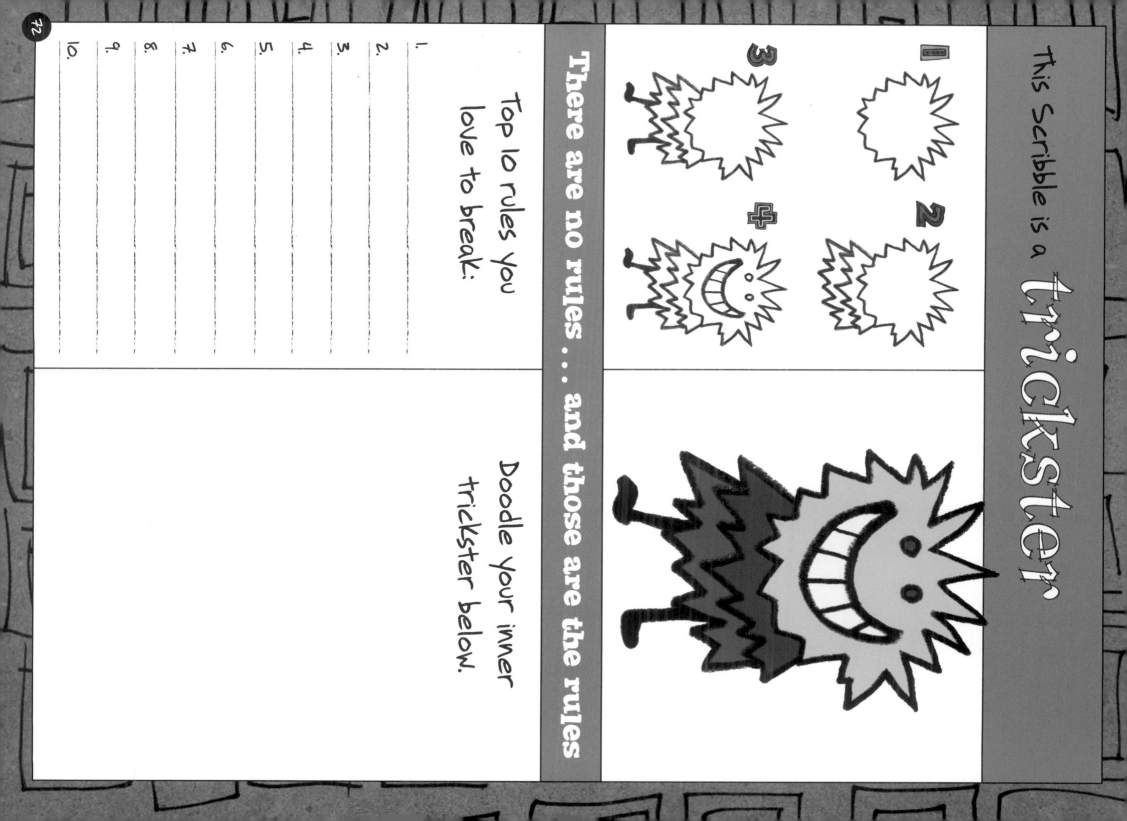

There are no rules . . . and those are the rules

Top 10 rules you love to break:

1.
2.
3.
4.
5.
6.
7.
8.
9.
10.

Doodle your inner trickster below.

Coloring outside the lines isn't just fun. It's necessary!

Maybe you're bored. Maybe you're suffocated by too many rules. Or perhaps you just thrive on spontaneity. Regardless of what's motivating you, this part of you yearns to shake things up by playing pranks, breaking rules, and causing mayhem at every turn—and this Scribble reflects that. He has an endless appetite for antics. The bigger and more innocent his smile, the more you know he's up to no good. This one's always scheming new ways to keep people on their toes, if only to force them to enjoy their lives and laugh a bit more. So, in a way, he believes that all his immaturity and absurdity is really for our own good. Because of his good intentions, this Scribble is rarely reckless or spiteful. Sure, some schemes get carried away. In hindsight, he probably should've fed the wolves before letting them into your office. Yet this Scribble relishes an elaborately plotted prank or a clever act of rebellion. And he prefers snickering behind the curtains over dancing on stage. That's why you're his main act. You just don't know it until you hear the fart of his whoopee cushion. And by then, all you can do is give him credit for getting you yet again.

What's the most daring and rebellious thing you've done as an adult? Doodle it here.

What prank would you pull if you thought you could get away with it? Doodle it here.

Scribbles Dating Game.
Draw each Scribble's perfect mate.

Name:
Occupation:
Looking For:

Name:
Studied:
Favorite Band:

Name:
Occupation:
Favorite Foods:

Name:
Astrological Sign:
Favorite Pastime:

This Scribble is a **blowhard**

1

2

3

4

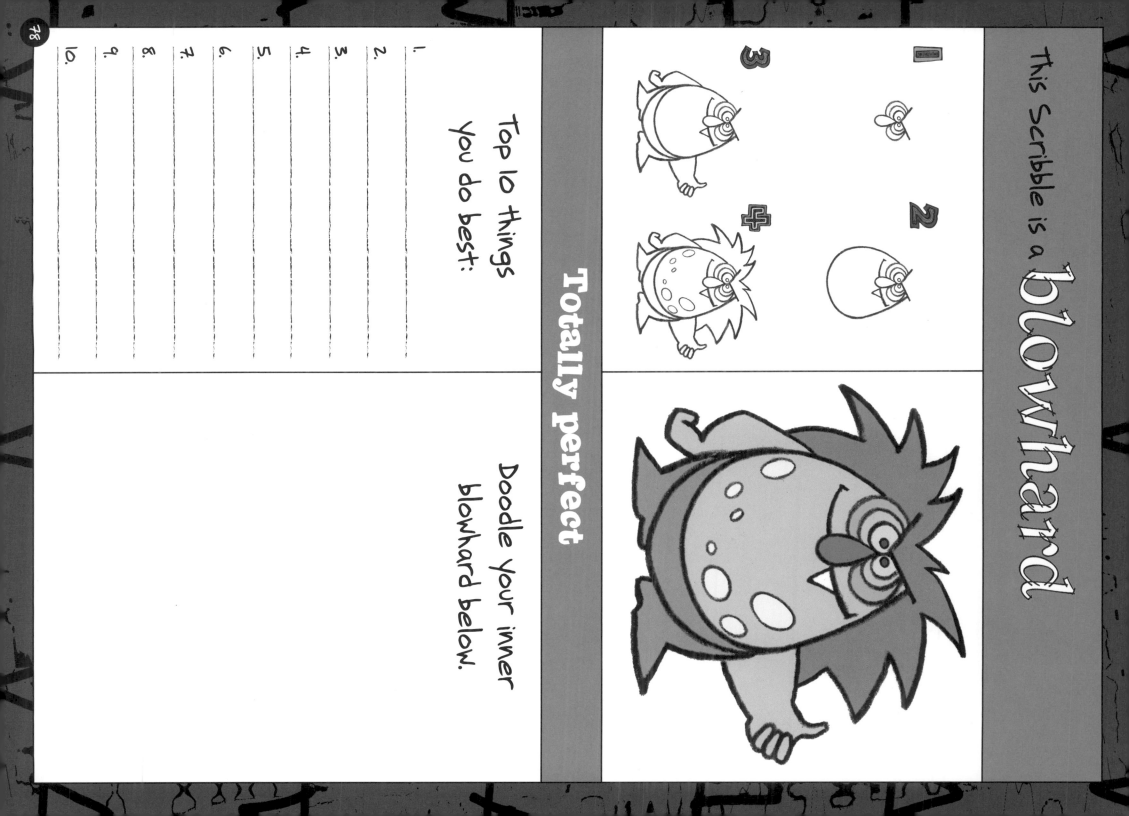

Totally perfect

Doodle your inner blowhard below.

Top 10 things you do best:

1. _____
2. _____
3. _____
4. _____
5. _____
6. _____
7. _____
8. _____
9. _____
10. _____

I'm a jack of all trades, baby!

This Scribble is the overly confident guy who calls everyone "Sport," "Tiger," "Champ," or "Sweetie," even if he knows their names. He's just delighted to hear himself talk, and everything he says or does is meant to impress others. This Scribble has dined at the best restaurants, read all the classics, met all the movie stars, and traveled around the world and back again. And he loves to talk "intelligently" about any topic, regardless if he knows anything about it. It's surprising how many credentials he claims to possess. From brain surgery to deep-tissue massage, he's somehow done it all. But will you ever see him fly that chopper or cook that four-star dinner? Nope. He'll somehow find an excuse to avoid proving his endless qualifications. So why tolerate this arrogant blowhard? Though he acts tough, he obviously means well. He just wants people to like him. So as long as you welcome him into the fun, he's harmless (if not entertaining). And even if you didn't invite him, he'd manage to show up anyway. In a limo, no less. So all in all, it's just easier to allow him to tag along.

What is your single most impressive accomplishment? Doodle it here.

Feel like bragging for no reason at all? Go ahead and do it on these pages. Who's going to know?

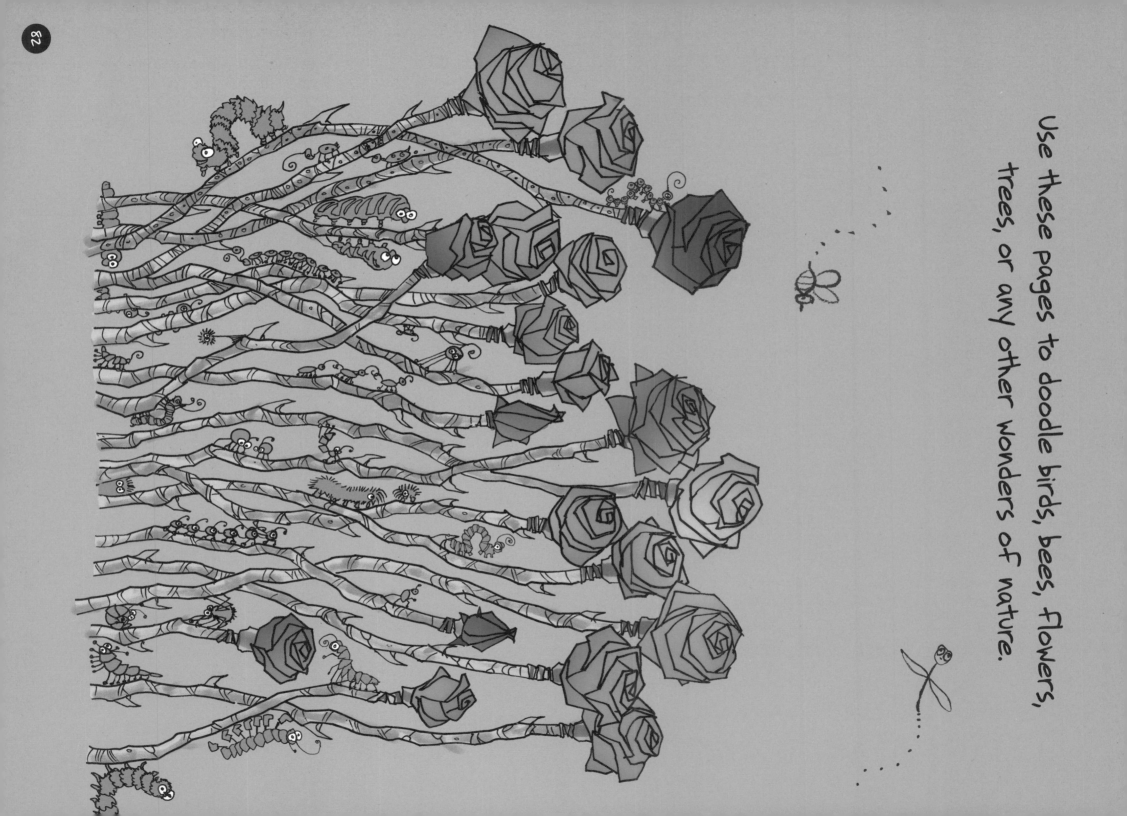

Use these pages to doodle birds, bees, flowers, trees, or any other wonders of nature.

This Scribble is a **Softy**

1
2
3
4

I love it! I love everything!

Top 10 things you love most:

1. _____
2. _____
3. _____
4. _____
5. _____
6. _____
7. _____
8. _____
9. _____
10. _____

Doodle your inner softy below.

I wear my heart on my sleeve

Ever gaze in awe at the simple beauty of a sunset? Ever give one of those never-ending hugs, just because? Ever secretly write the name of your crush on your notebook? Did you even draw hearts around it? Yep, this romantic Scribble lives in all of us. She's the kissy, flirty, mushy, cheesy, cuddly, snuggly, lovey-dovey type that lightens your step and makes you float when life is truly good. Being such a softy, this Scribble tends to only see the good in things. The darker the cloud, the more shiny the silver lining. So when that cloud inevitably rains on her parade, she's somehow surprised. Shouldn't things always go perfectly? Shouldn't everybody get along? Some find her optimism endearing. Most just think she's gullible and naïve, which (by the way) makes her easy prey for pranksters. Tell her there's gold at the end of that rainbow, and she'll walk 500 miles before she realizes you were joking. And she's so sweet, she'll actually find it funny.

What is your idea of a perfect world? Doodle it here.

What are you feeling especially optimistic about today? Doodle it on these pages.

AFTER:

What did BEFORE look like?

BEFORE:

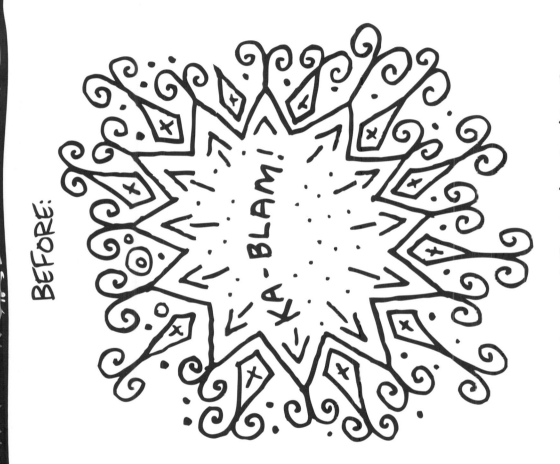

KA-BLAM!

What does AFTER look like?

These Scribbles are at the opening of an art exhibit featuring the work of a very famous doodler—you!

Trace, copy, or color the design on this page.

This Scribble is a **bore**

1 2 3 4

I really have nothing to say.

Top 10 things you care about least of all:

1.
2.
3.
4.
5.
6.
7.
8.
9.
10.

Doodle your inner bore below.

Wait—don't tell me.
No, really, don't tell me.

It's just after lunch. The world blurs into a shapeless, colorless mush that you have no interest in whatsoever. Your pencil begins moving around the page, and suddenly what springs to life is this little Scribble, who is absolutely, hopelessly, exhaustingly bored. There is nothing in this world that excites him. Everything is lame. Everyone is lame. Nothing is fun. In fact, the sheer existence of fun is debatable, if not a laughable myth. If he laughed, that is. Because he doesn't. Ever. Laughing is lame. That's why when asked if the glass is half full or half empty, his response is always the same. "Meh. Who cares?"

What's the most boring story you've ever heard? Doodle it here, but change it from boring to fantastic.

What would you rather be doing than doodling in this doodle book? Doodle it here.

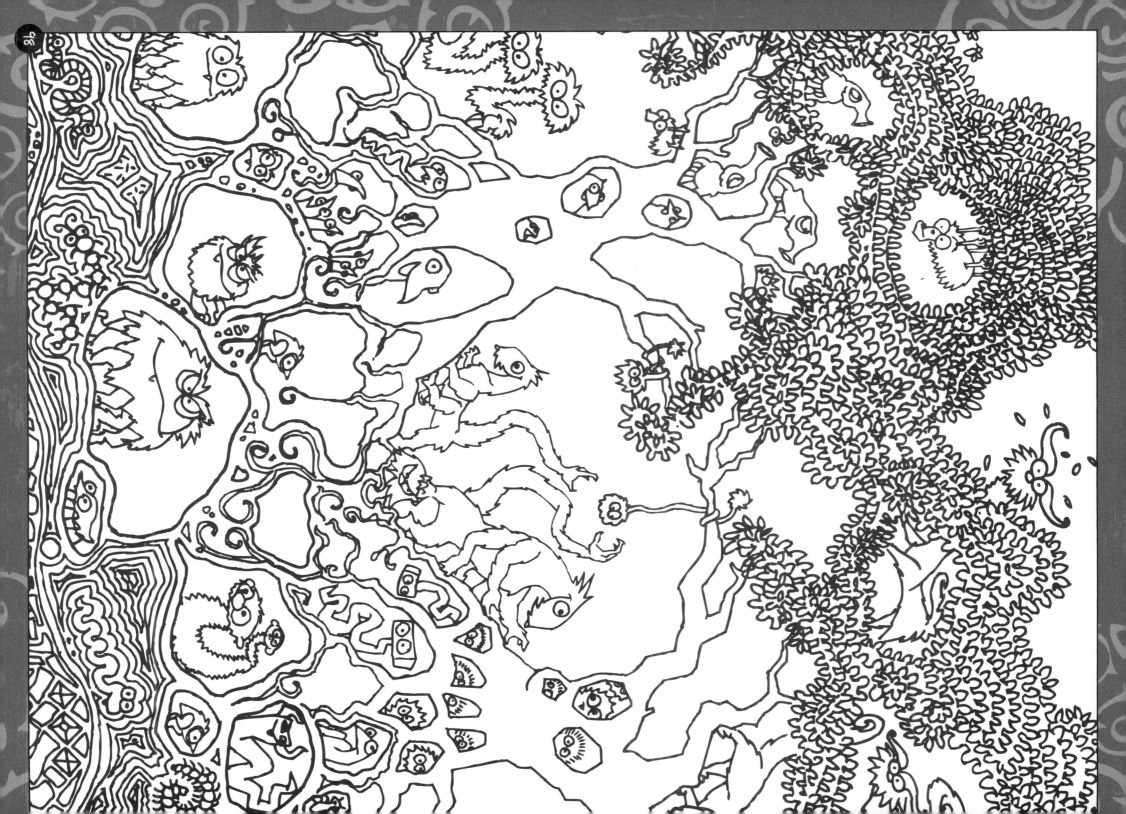

Continue the drawing at left on this page.

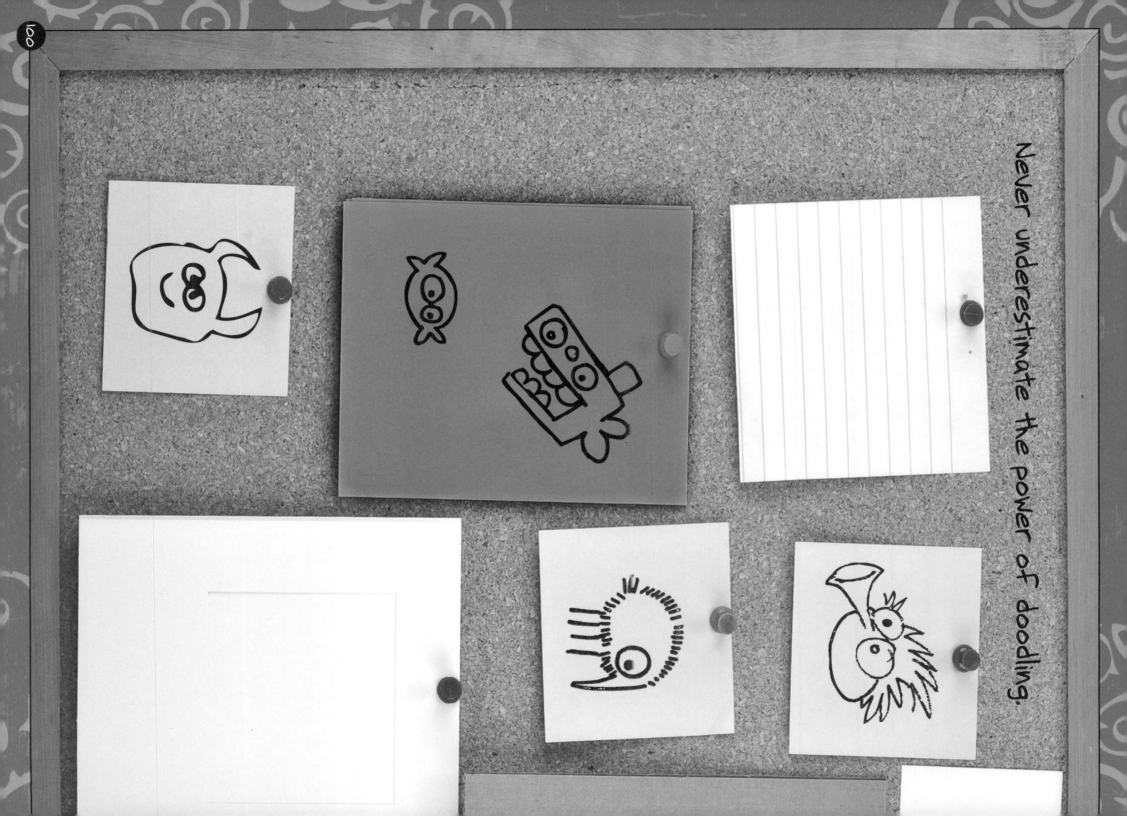

Never underestimate the power of doodling.

Do it, and do it often.

This Scribble is totally **awkward**

1
2
3 +

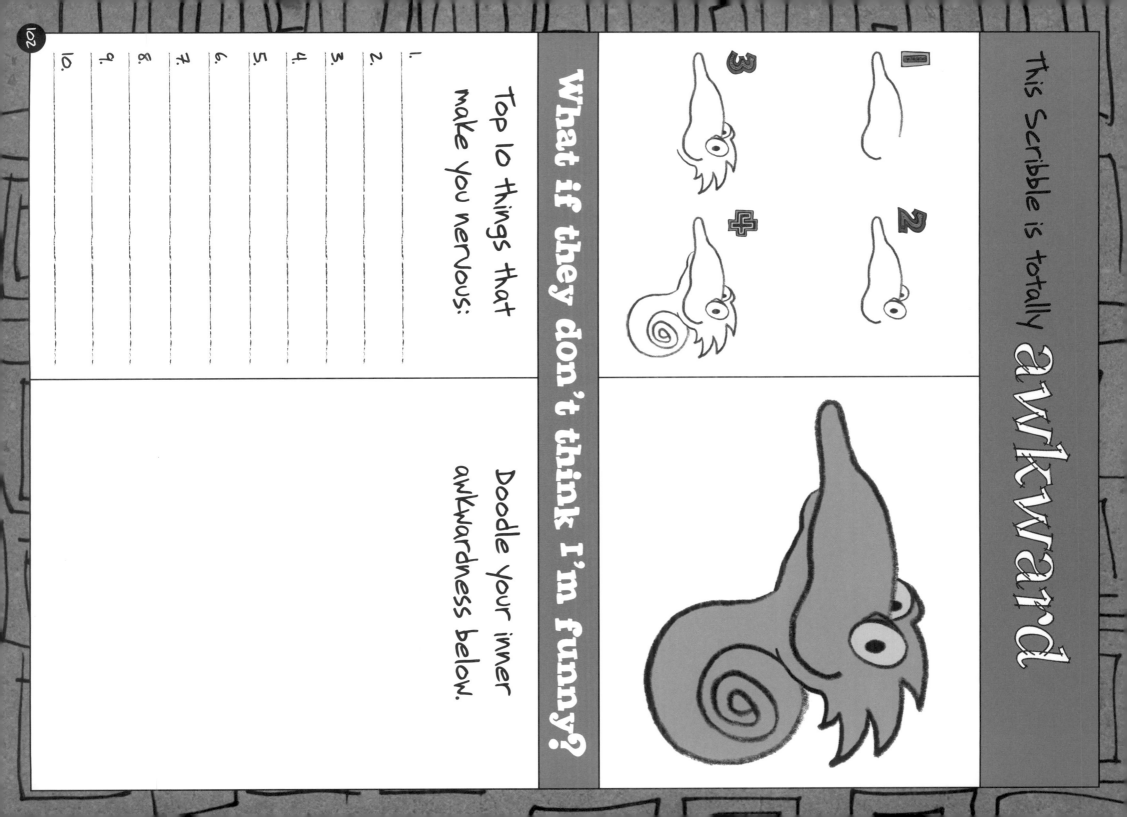

What if they don't think I'm funny?

Top 10 things that make you nervous:

1.
2.
3.
4.
5.
6.
7.
8.
9.
10.

Doodle your inner awkwardness below.

Ill at ease, painful, congested, accident prone.

Butterflies in your stomach. Cotton mouth. Can't think straight. All the symptoms you get right before you talk to your crush. Before you take that big test. Before the big game. Even the simplest tasks are complicated by a mess of emotions, as you melt into a mush of awkwardness and anxiety. This Scribble spaz is incapable of making decisions, and he's socially awkward to the point of incapacitation. He sweats. Stinks. Stutters. Slimes. Sneezes. Wheezes. He's a total mess when he's nervous... and that, unfortunately for our Scribble, is quite often. Yet deep inside, he is a ball of untapped potential for greatness. He just doesn't know it. He's smart, dependable, and the best friend you could ask for (if you can tolerate his neuroses). And when a crisis arises, he will impossibly brave his fears and do the right thing. With a helpful nudge and the right timing, you'd be surprised what this Scribble can do.

What is the most awkward moment you've ever had?

Doodle it here.

Feeling anxious?
Doodle your cares away on these pages.

(Your doodle prompt here.)

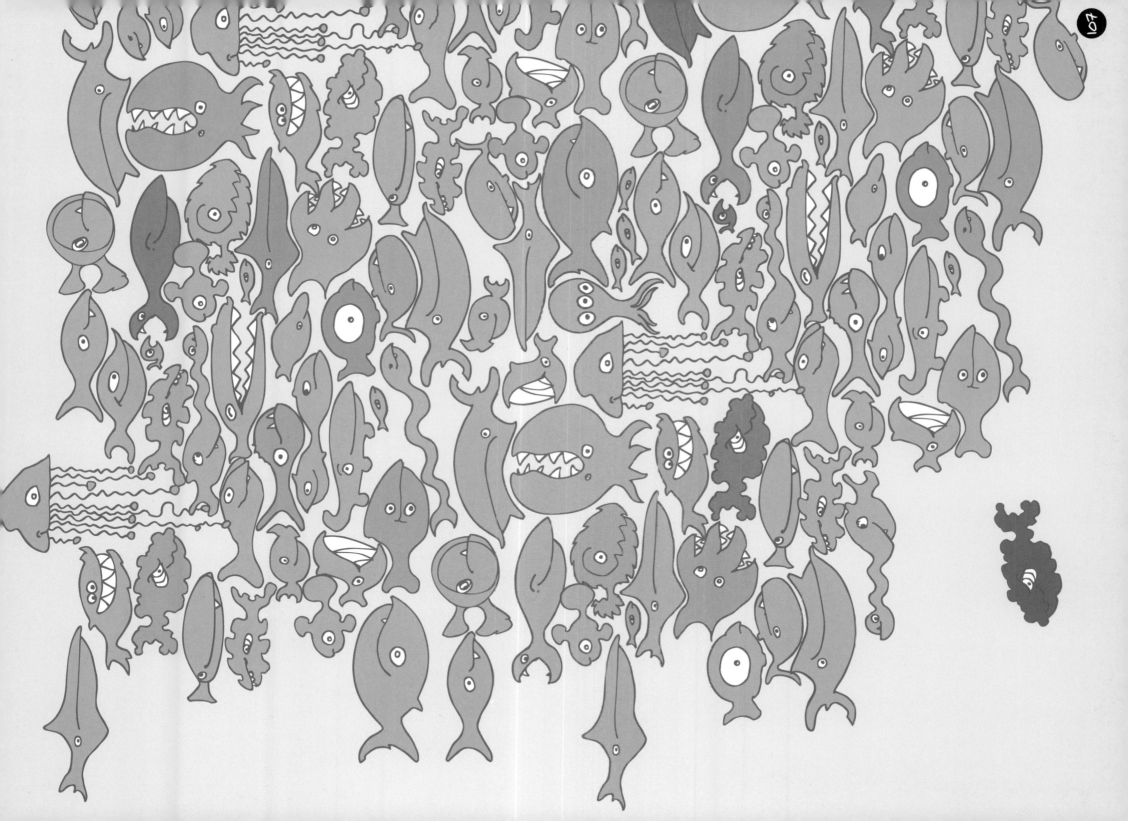

This Scribble is a jester

3

2

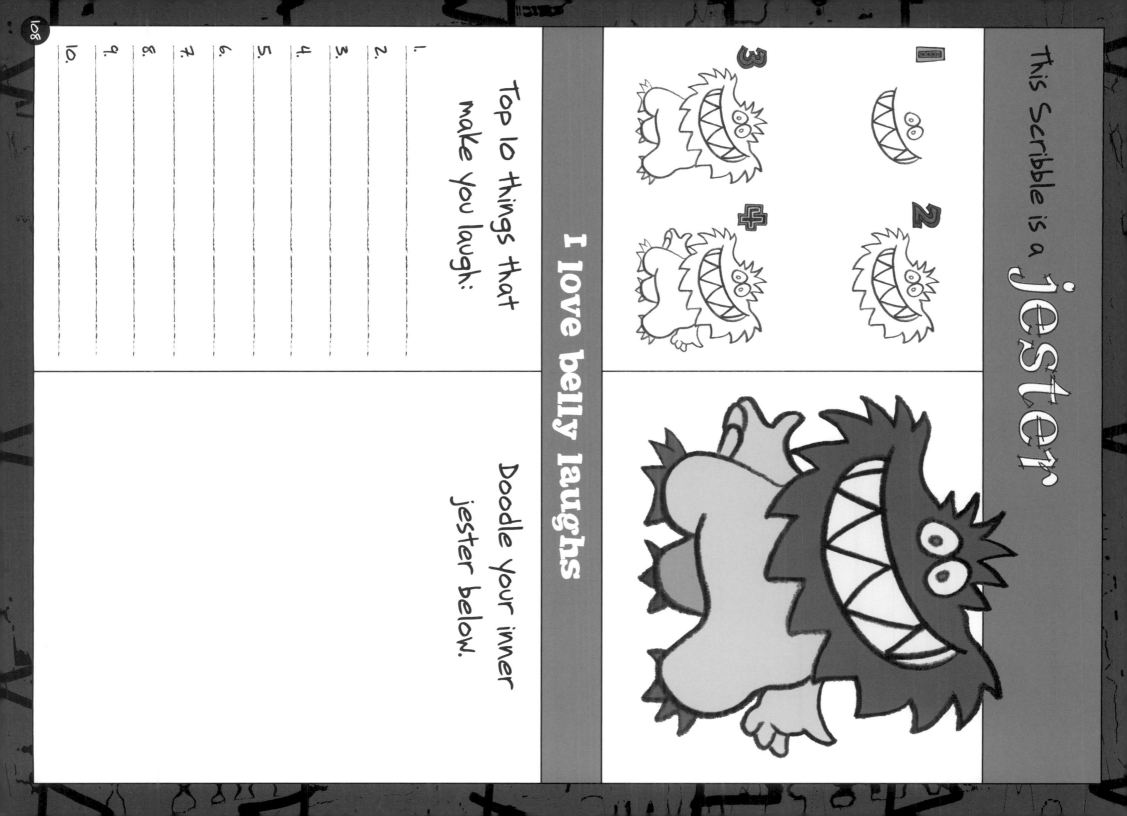

I love belly laughs

Top 10 things that make you laugh:

1.
2.
3.
4.
5.
6.
7.
8.
9.
10.

Doodle your inner jester below.

109

Chickens crossing the road are overrated

In real life, most of us fumble jokes, trip over pick-up lines, and sweat whenever the spotlight casts our way. Yet in our minds, we're all creative geniuses. No matter how many botched jokes and awkward silences, there's a small part of us that never learns—like this Scribble, who tries too hard. She's so eager to please that she'll dance, sing, and throw herself all over the page if it'll make someone laugh. Unfortunately, she hasn't really mastered the art of punchlines or storytelling. Her jokes are either timed wrong, obscure, too complex, or not complex enough. So no matter what, she's always standing there with jazz hands and a waning smile... wondering why nobody's laughing.

What's the funniest thing that happened to you yesterday (or last week, last month, last year)?

Doodle it here.

Work up a comedy sketch using
a variety of characters.

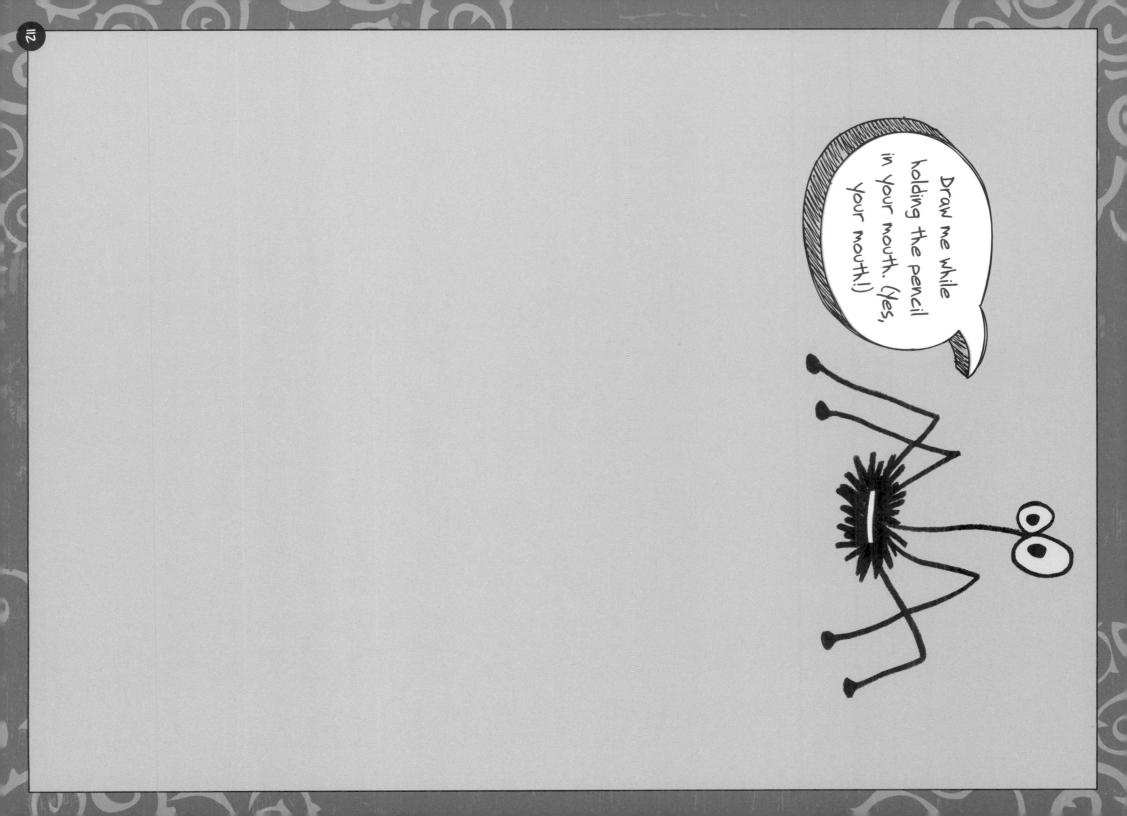

Using these colorful borders as inspiration, draw your own patterned doodle designs.

Using the butterfly tree as inspiration, doodle a tree incorporating your favorite animal, food, or object. How about a pizza tree, balloon tree, or giraffe tree?

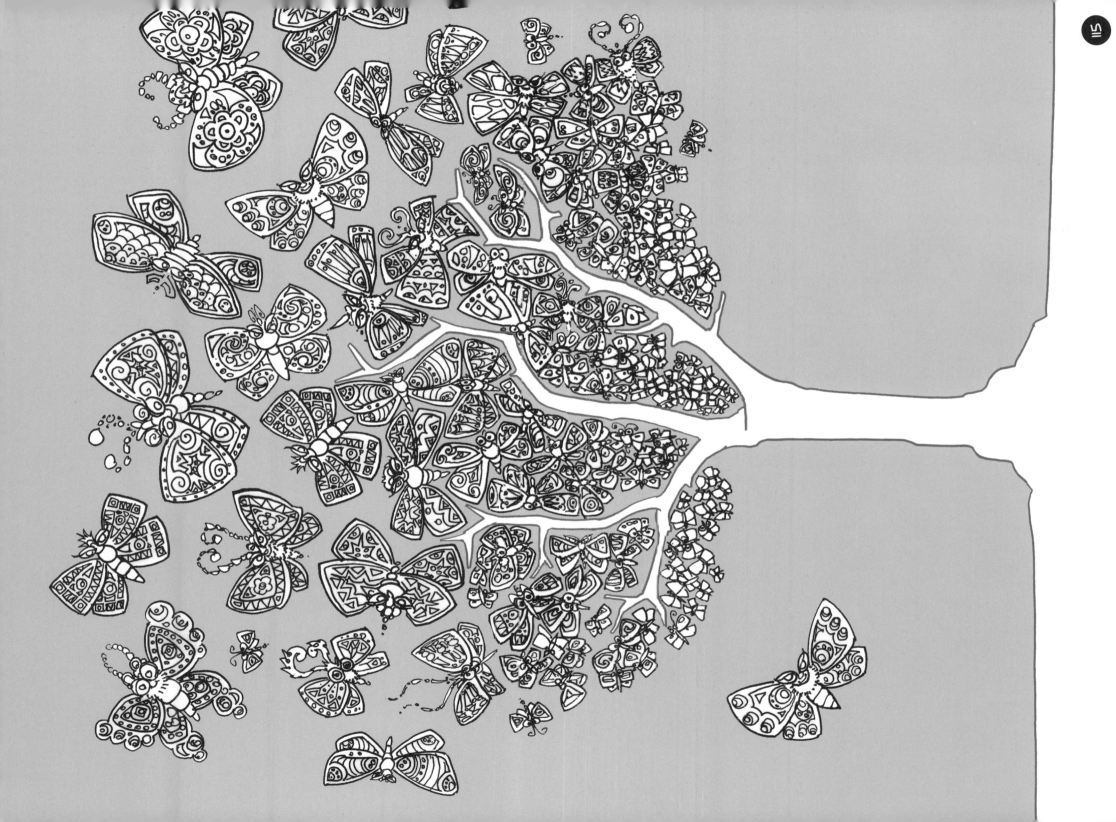

This Scribble is a *rebel*

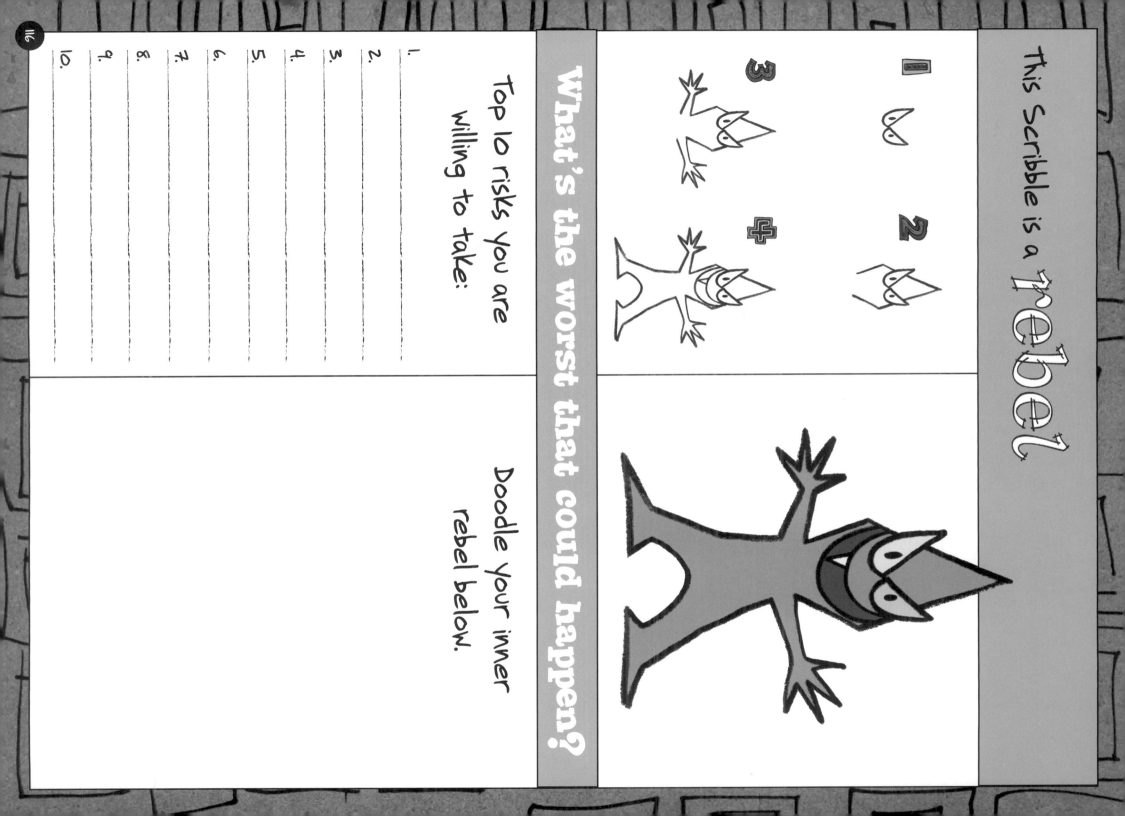

1

2

3

4

What's the worst that could happen?

Top 10 risks you are willing to take:

1. _____
2. _____
3. _____
4. _____
5. _____
6. _____
7. _____
8. _____
9. _____
10. _____

Doodle your inner rebel below.

I'm a 10 on the Richter scale

"No." That's our rebel's favorite word. Unless you want to hear the word "no." Then his favorite word is "yes." This Scribble is your stubbornly reckless side. The rebel without a cause, confronting authority and questioning the rules at every turn. It's not that this Scribble enjoys being confrontational. Well, maybe he does a little. (Okay, maybe a lot.) If we're being honest with ourselves, we all crave drama from time to time. And even when you're screaming your head off, at least it's not boring. That's why this Scribble fights against the grain. Despite all the drama, it's a guaranteed cure for boredom. So if there's a button, he'll push it. Even if it's unlabeled. Even if it's a button at a nuclear power plant. He lives off the thrill of pushing the envelope, so don't trust him with power tools or sharp objects. To be frank, don't trust him at all. So when this guy volunteers to bake the birthday cake, set up the fireworks, or plan that big event, just know what you're getting into. It might be the most fun you've ever had, but you might also find yourself in another madcap catastrophe...with this guy giggling all the way.

What do you do to shake things up? Doodle it here.

Feeling rebellious? Doodle here what you could NEVER do in real life.

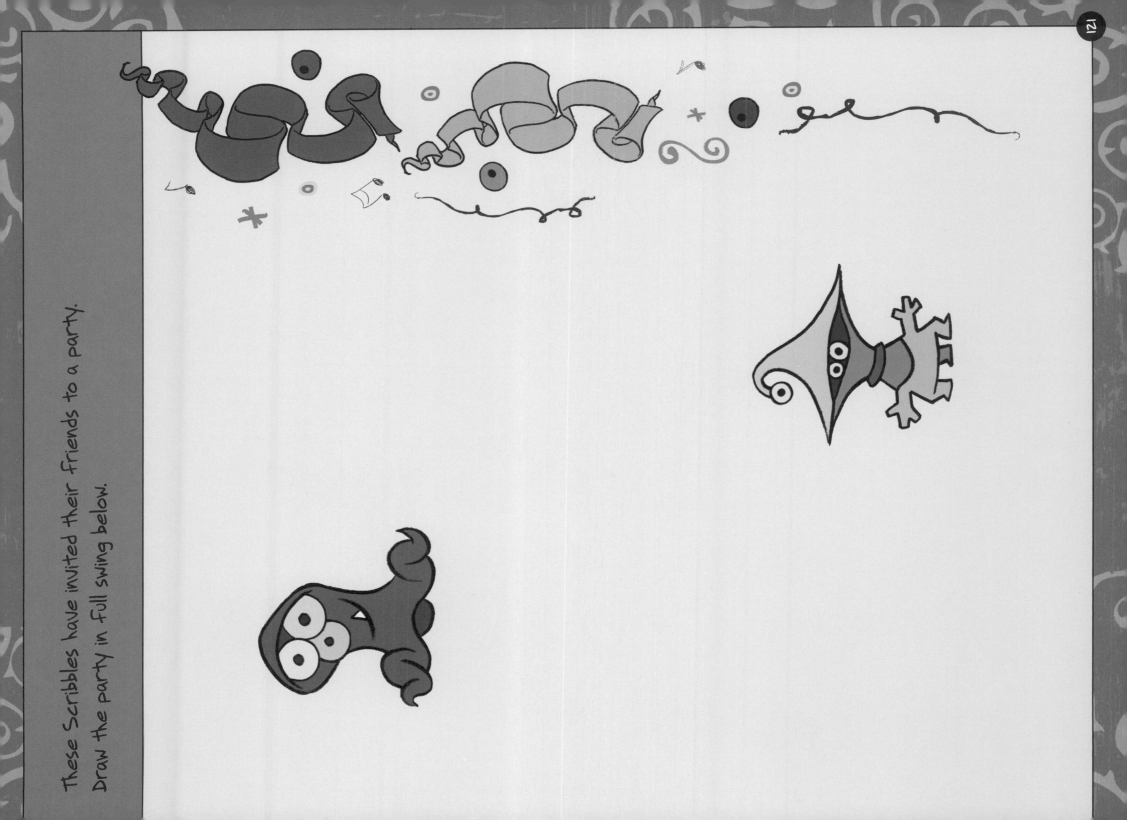

These Scribbles have invited their friends to a party. Draw the party in full swing below.

This Scribble is a *diva*

3

2

I'm amazing! Seriously.

Top 10 most fabulous things about you:

1.
2.
3.
4.
5.
6.
7.
8.
9.
10.

Doodle your inner diva below.

123

All this and modest, too!

That's our diva Scribble. She is beautiful, glamorous, and happy to let everyone know it. She's that part of you who looks in the mirror and says, "Hey beautiful." The one who craves being on the Red Carpet. Don't read her wrong, though. Even though she's got a whopping ego, she's not blind to the needs and feelings of others. Just the opposite. She wants everyone to look and feel as fabulous as she does! She's happy to throw a huge party for her friends, just as long as she is the center of attention, she looks fabulous, and everything goes according to her plans. But when things don't, whoa! She'll stomp and shout until her feathers fall out. She might be sweet, but she demands star treatment.

What would your life be like if you were a superstar? Doodle it here.

Doodle yourself as a world-famous rock star, actor, athlete, or other celebrity.

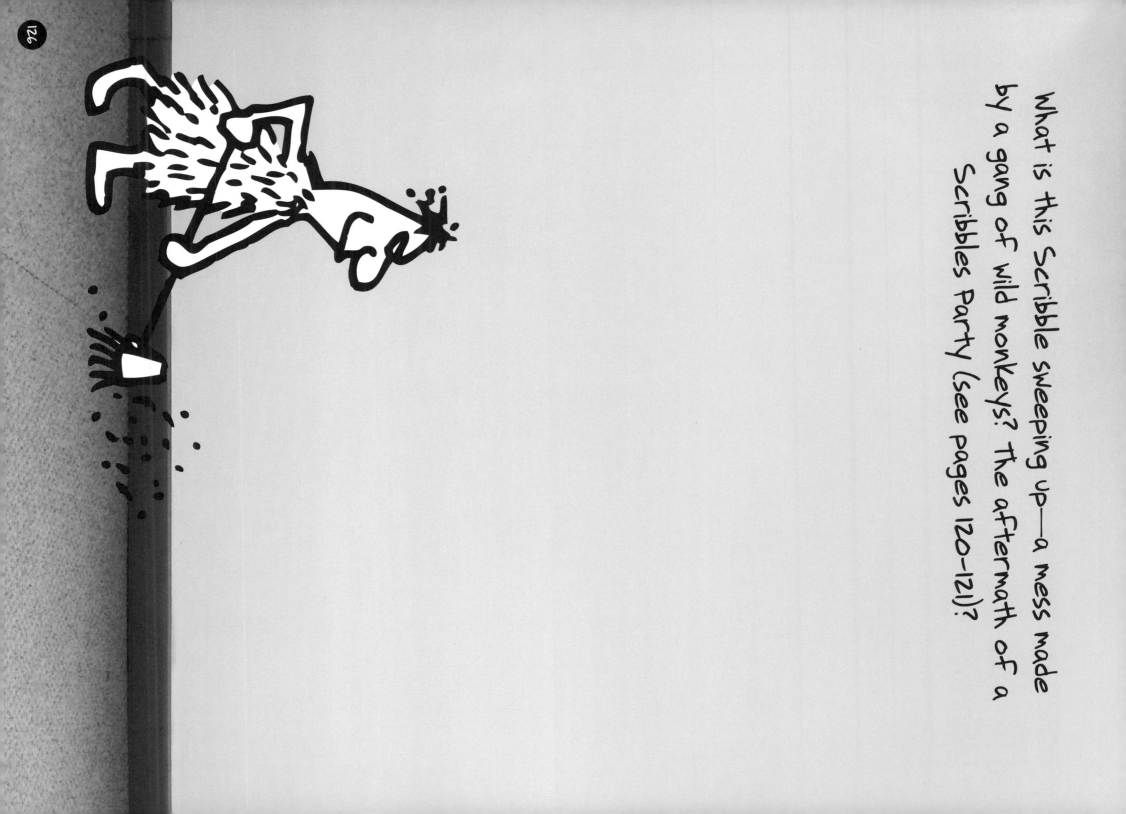

What is this Scribble sweeping up—a mess made by a gang of wild monkeys? The aftermath of a Scribbles Party (see pages 120-121)?

Study the Scribbles. Then close your eyes and try to draw them from memory. No peeking!

"Life is meant to be fun, and joyous, and fulfilling. May each of yours be that."

—Jim Henson